Cambridge Ontario Part 2: Preston in Photos, Saving Our History One Photo at a Time

Photography
by Barbara Raué
2013

Series Name:
Cruising Ontario

Book 40: Preston

Cover photo: 1115 Duke Street

Series Name: Cruising Ontario

Book 1: London
Book 2: Dundas
Book 3: Hamilton
Book 4: Oakville
Book 5: Chesley
Book 6: Stoney Creek
Book 7: Waterdown
Book 8: Owen Sound
Book 9: Mount Forest
Book 10: Dundalk
Book 11: Burford
Book 12: Waterford
Book 13: Drumbo
Book 14: Sheffield
Book 15: Tavistock
Book 16: Ancaster and Mount Hope
Book 17: Innerkip
Book 18: Brantford
Book 19: Burlington
Book 20: Guelph
Book 21: Ayr
Book 22: Erin
Book 23: Goderich
Book 24: Lucknow
Book 25: Paris
Book 26: Toronto
Book 27: Beaver Valley
Book 28: Collingwood
Book 29: Peterborough
Book 30: Orangeville Beginnings Part 1
Book 31: Orangeville Part 2 and Area
Book 32: Port Elgin
Book 33: Southampton
Book 34: Jarvis
Book 35: Hagersville
Book 36: Caledonia
Book 37: Simcoe
Book 38: Galt Book 1
Book 39: Galt Book 2
Book 40: Preston
Book 41: Hespeler
Book 42: Kitchener
Book 43: Waterloo
Book 44: Shelburne
Book 45: Alton

Other Books by Barbara Raue

Coins of Gold

Arrows, Indians and Love

The Life and Times of Barbara
Volume 1: Inventions That Have Enhanced My Life
Volume 2: Entertainment That I Have Enjoyed
Volume 3: East Coast Trips
Volume 4: Olympics Have Always Intrigued Me
Volume 5: Wonders of the World
Volume 6: Caribbean Cruises We Have Enjoyed
Volume 7: Animals
Volume 8: Storms and Other Major Disasters in My Lifetime
Volume 9: Wars, Terrorist Attacks and Major Disasters

The Cromwell Family Book

Visit Barbara's website to view all of her books
http://barbararaue.ericraue.com

Preston

John Erb, the founder of Preston, was born in Lancaster County, Pennsylvania, a Mennonite of Swiss ancestry. He came to Upper Canada in 1805, acquired 7,500 acres of land from the German Land Company and settled on the site of Preston where the Grand and Speed Rivers meet. He built a sawmill and a gristmill and the community grew around them. The town was originally known as "Cambridge Mills" and was later renamed after Preston, England.

Preston's location on the Great Road into the interior of the province made it a natural stop for travellers and with its eight hotels and taverns attracted more Europeans than any other village in the area.

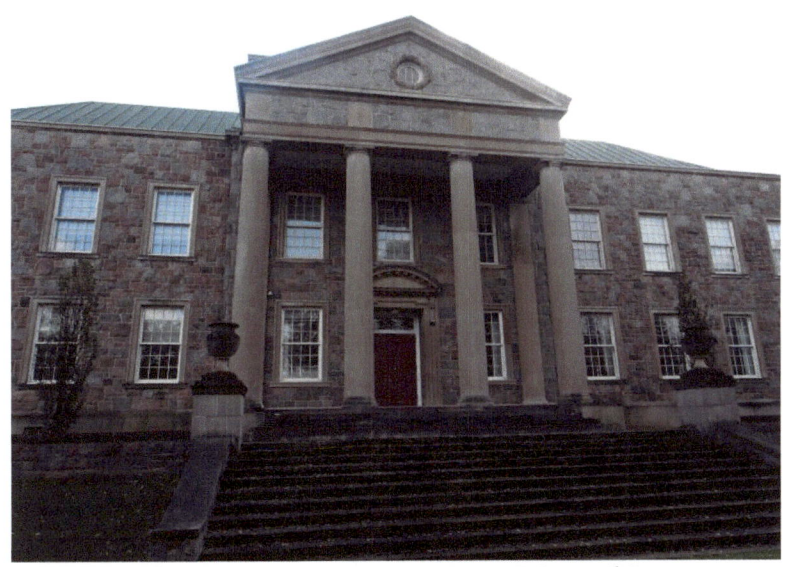

252 Dundas Street, Preston – Gore Mutual Insurance
1935

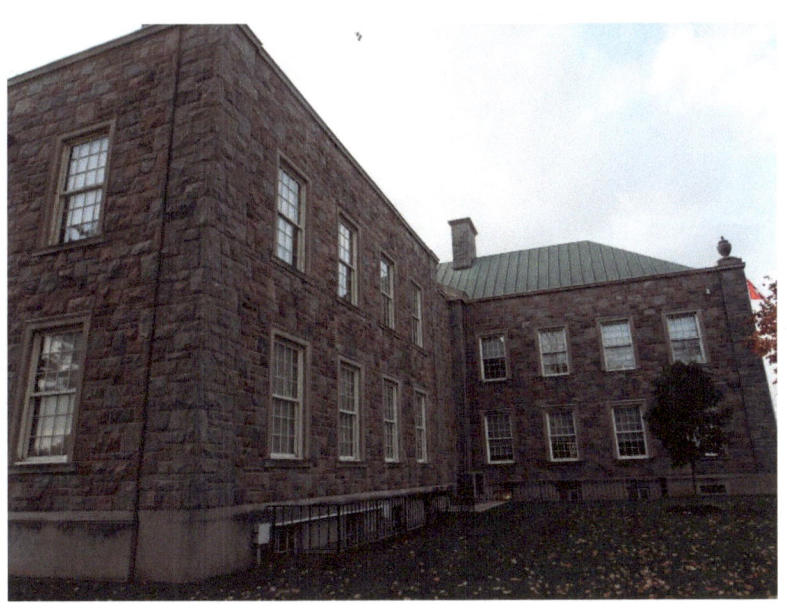

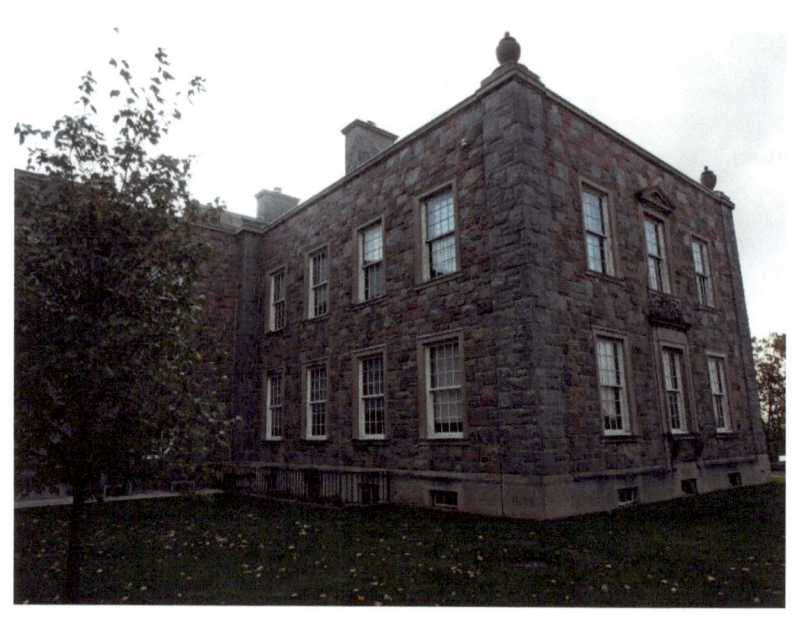

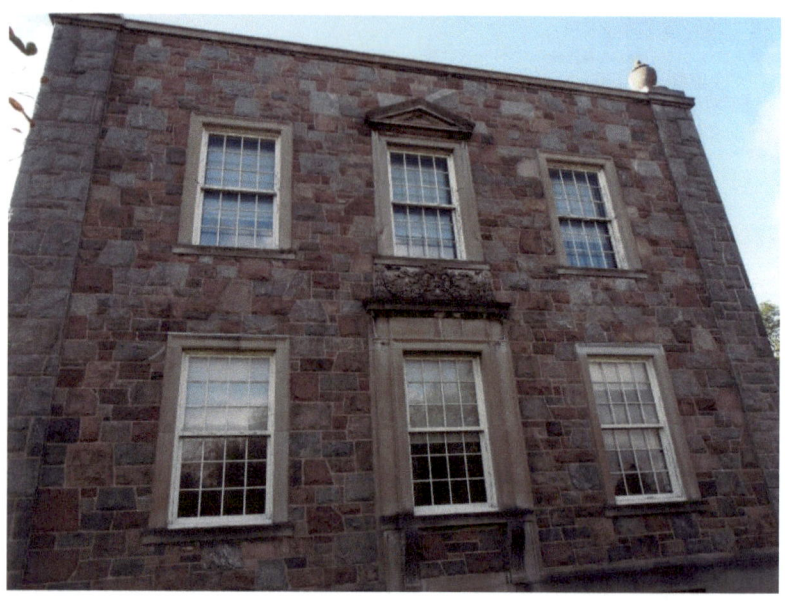

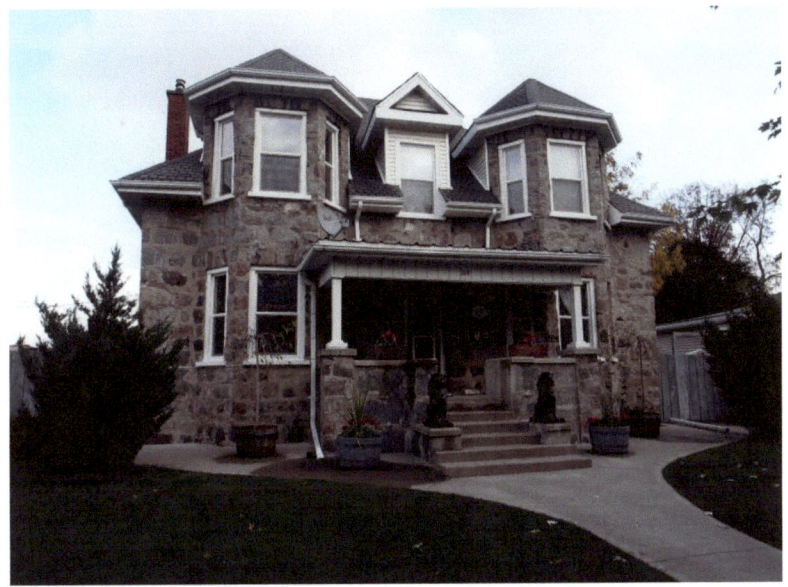

222 Dundas Street, Preston – cobblestone architecture – Italianate with two-storey tower-like bays on either side of the doorway; dormer in attic between the bays

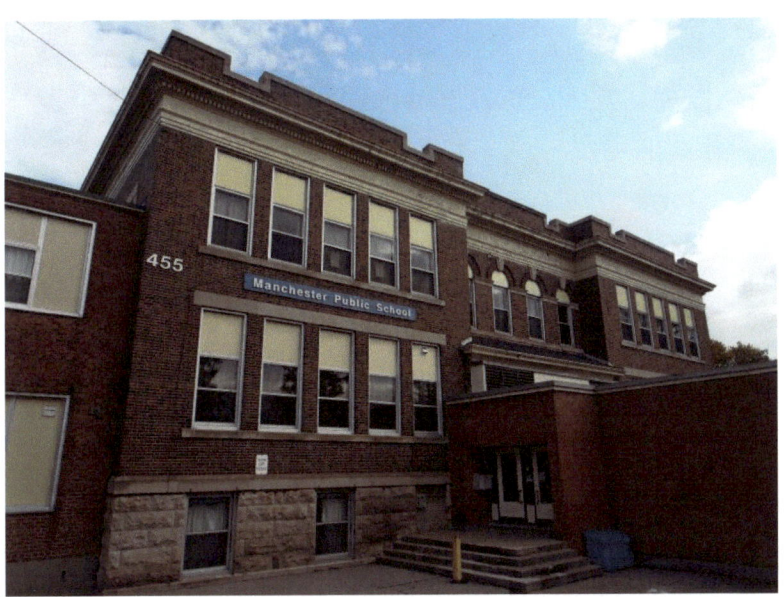

455 Dundas Street – Manchester Public School

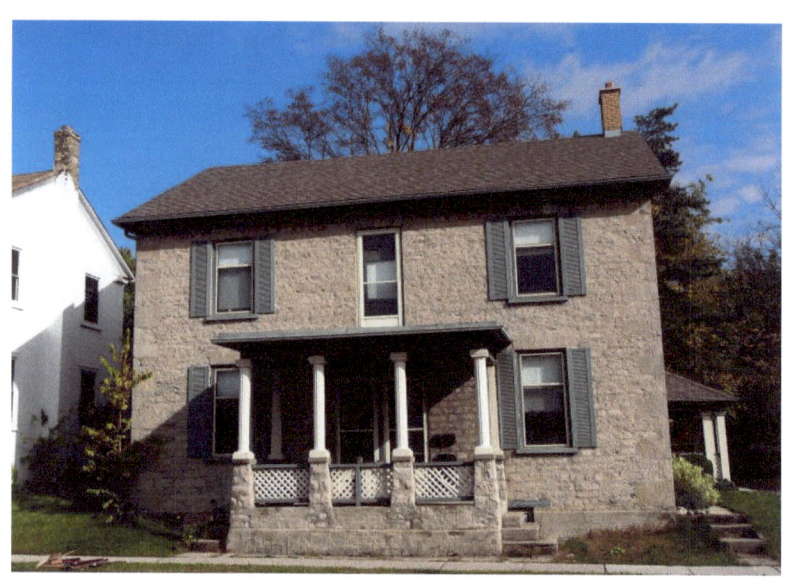

1341-1343 King Street

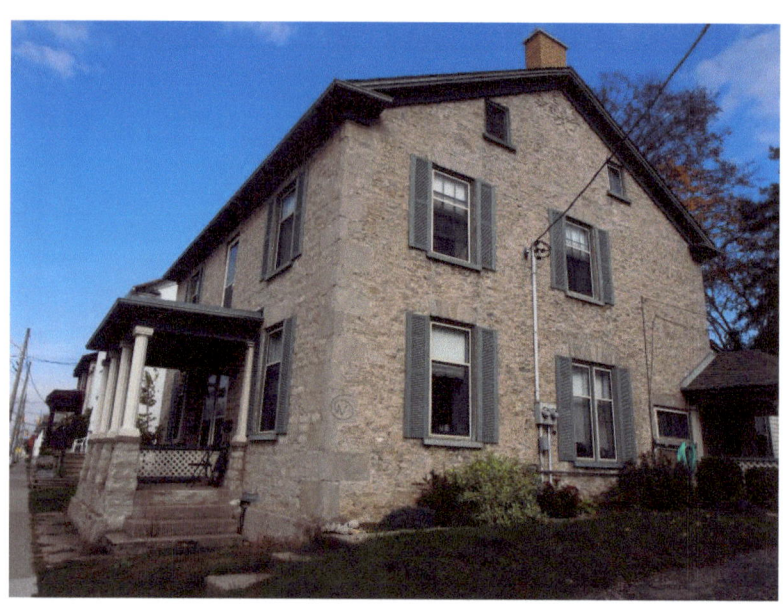

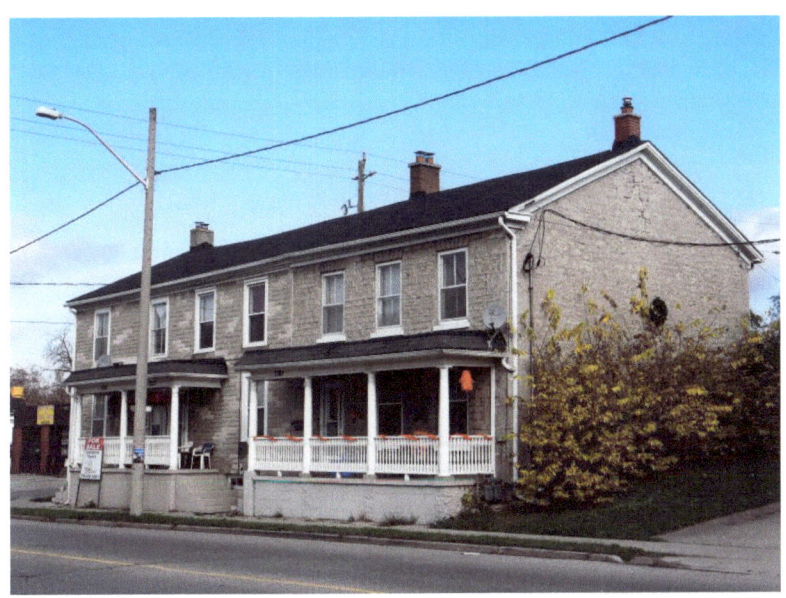

1305-1309 King Street

1270 King Street East – cobblestone

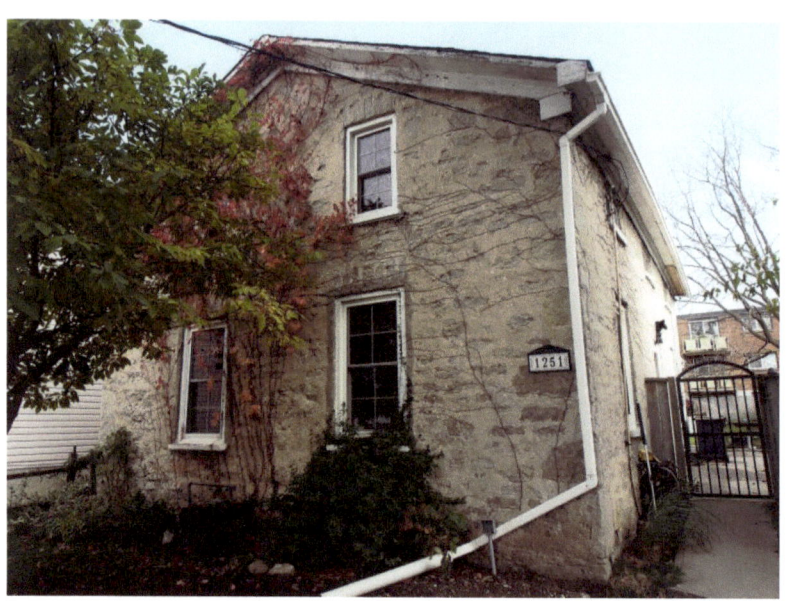

1251 King Street - cobblestone

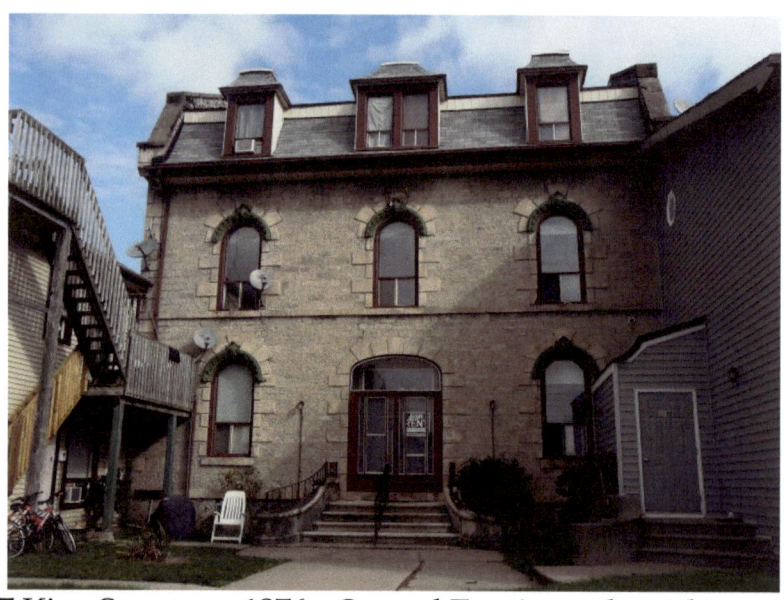

1107 King Street – c. 1876 – Second Empire style with mansard roof with dormers, decorative brickwork around windows, arched window hoods with acroterion keystones

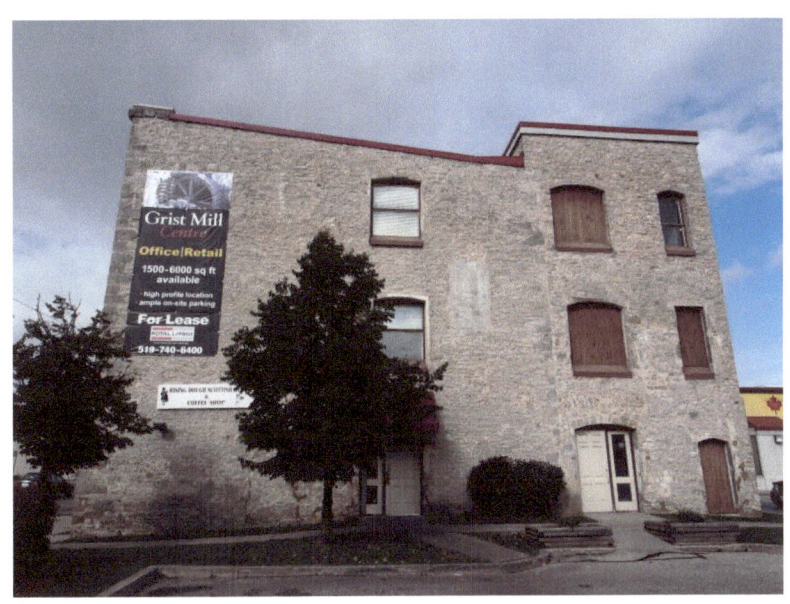

927 King Street East – Grist Mill Mall

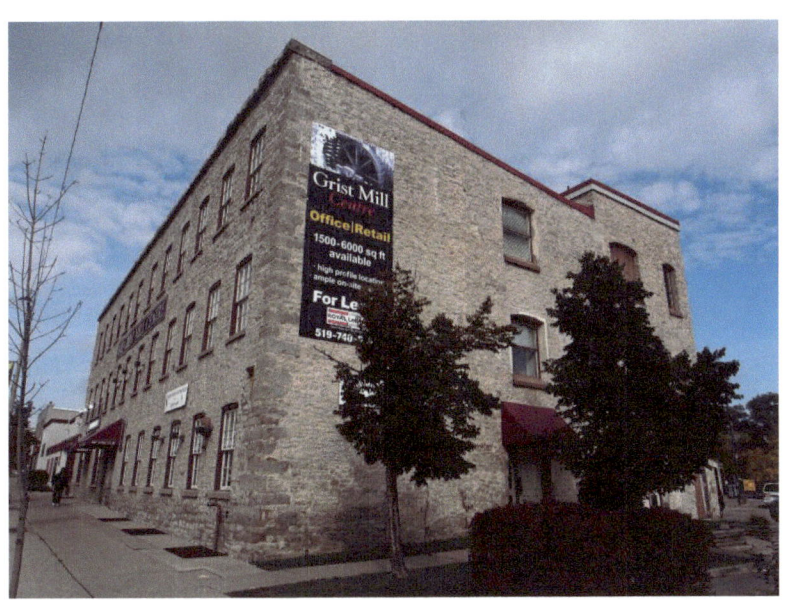

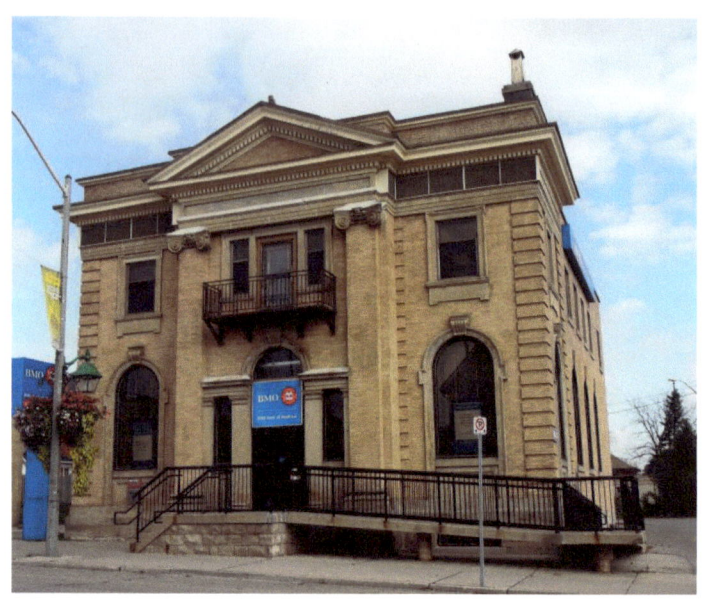

807 King Street East, Bank of Montreal – buttresses with scrolled capitals, dentil moulding, pediment, window voussoirs and decorative keystones

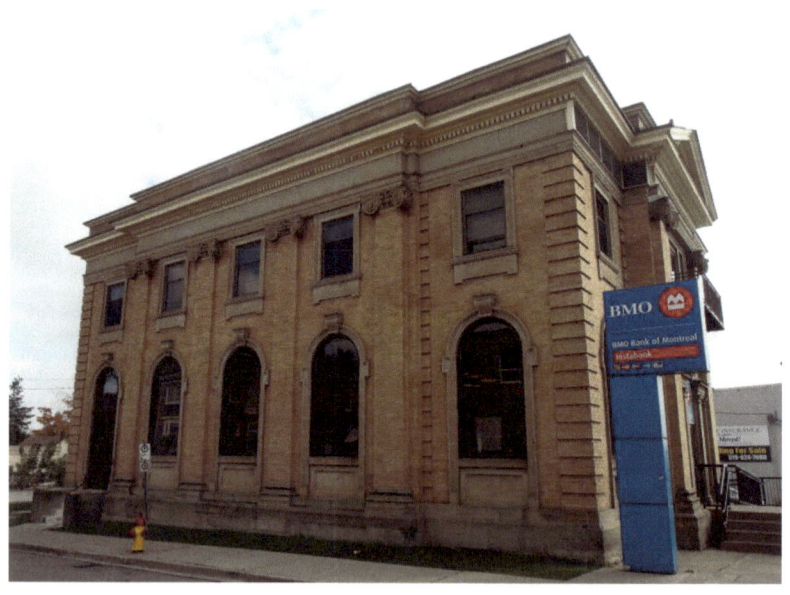

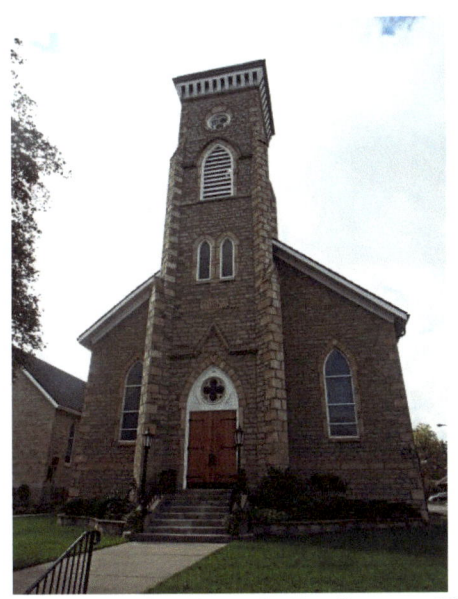

810 King Street East – St. Peter's Lutheran Church – 1887
Lancet windows

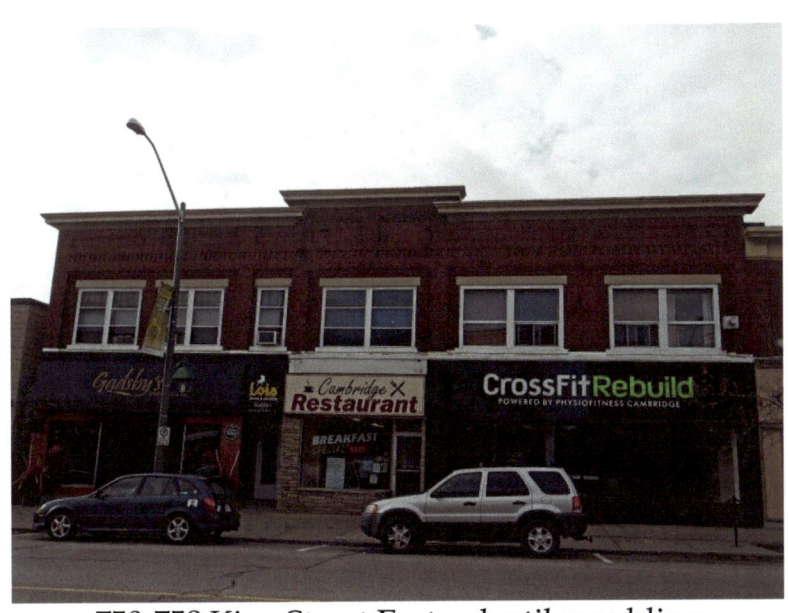

750-758 King Street East – dentil moulding

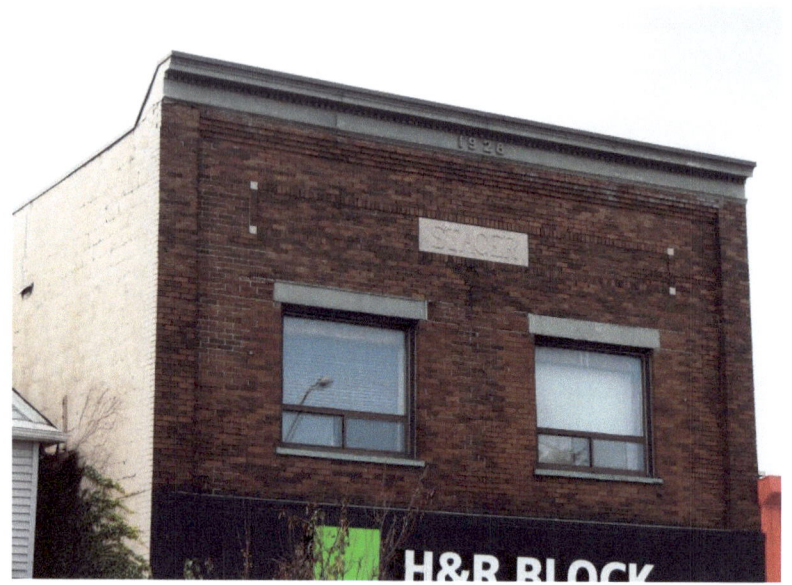
Stager Building – King Street - 1928

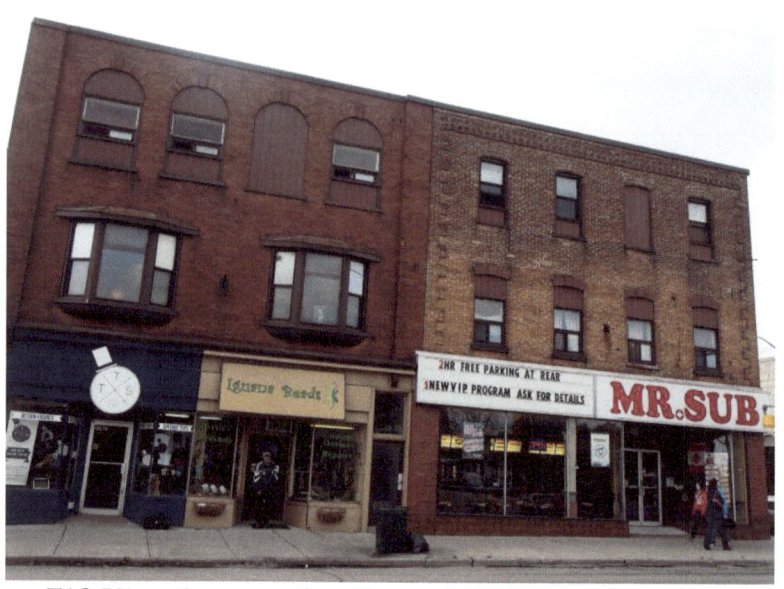
710 King Street – dentil moulding, corner quoins

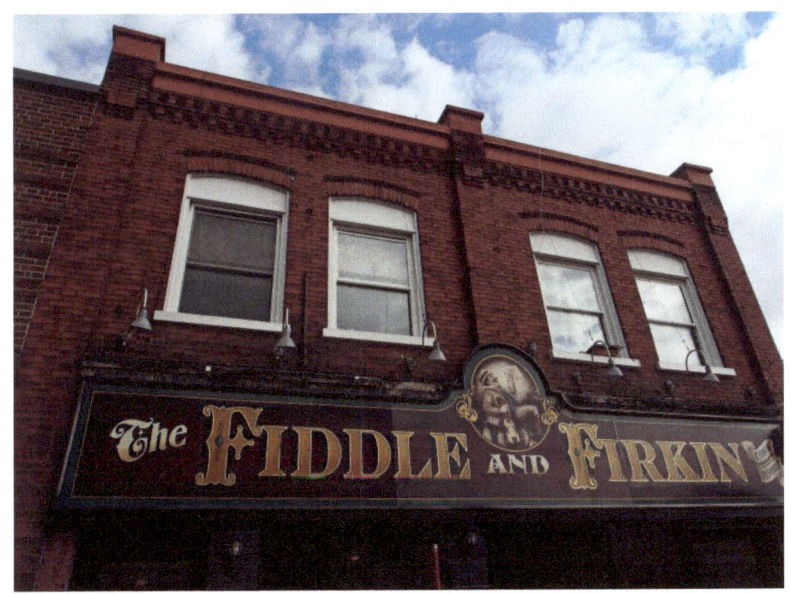

Dentil moulding

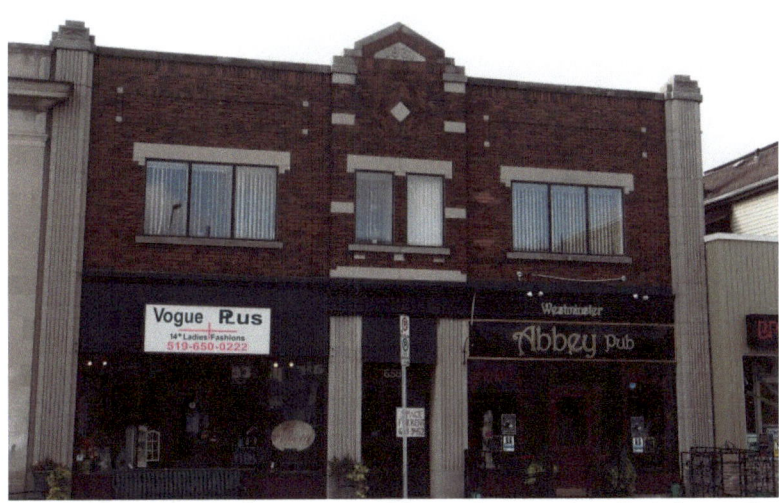

658 King Street East – c. 1931 – decorative brickwork

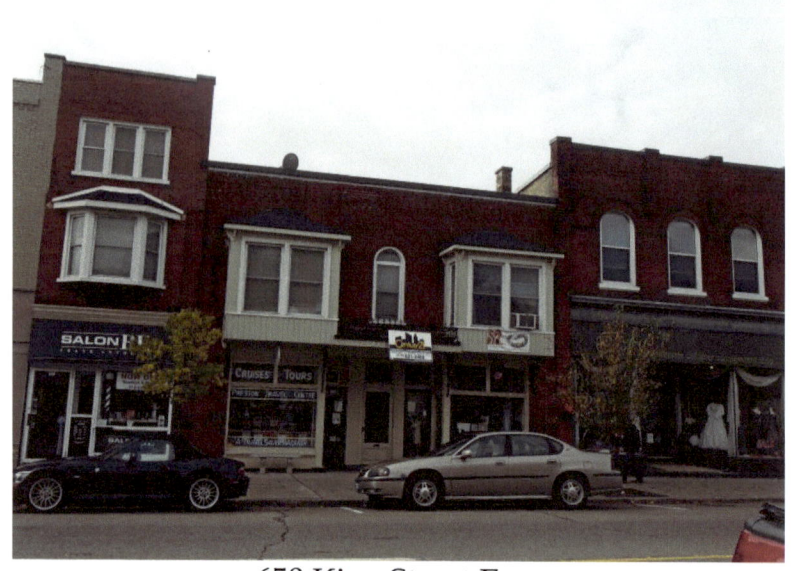

650 King Street East

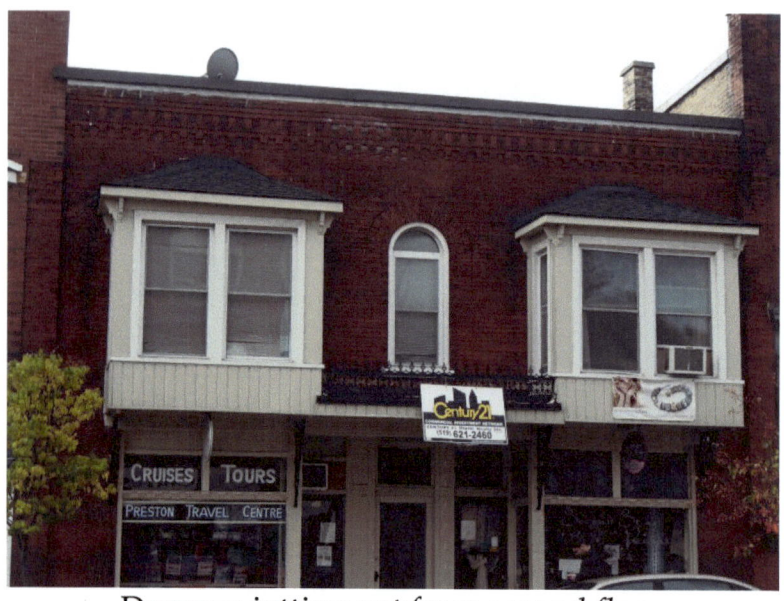

Dormers jutting out from second floor

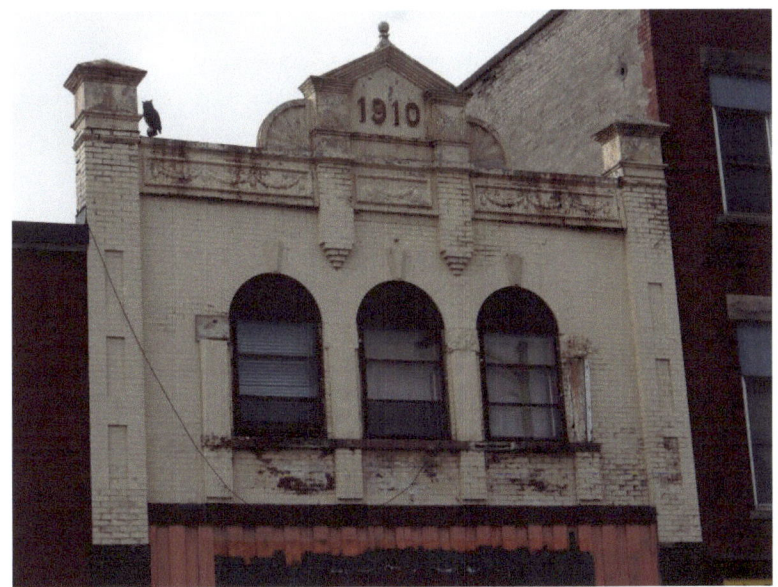

1910 decorative facade

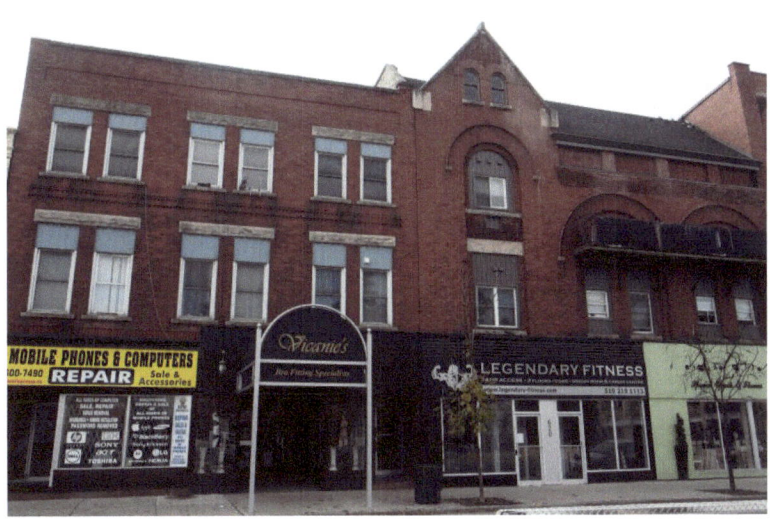

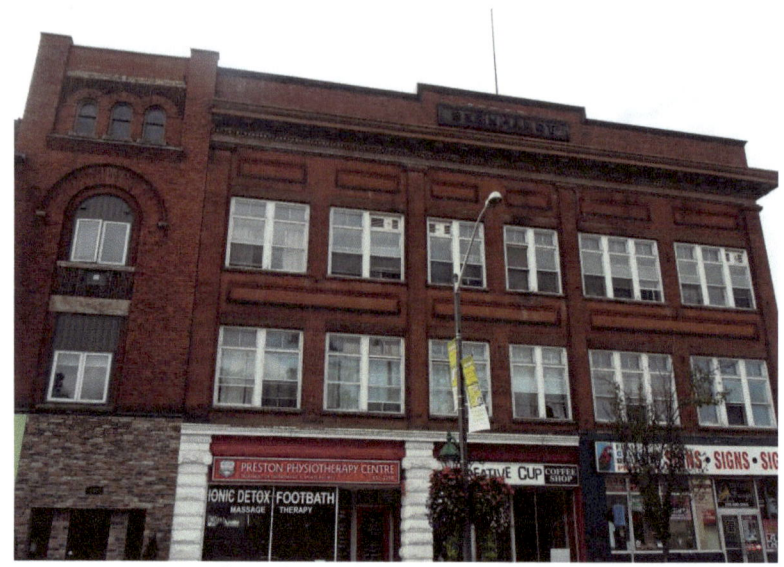

Bernhardt Building on King Street

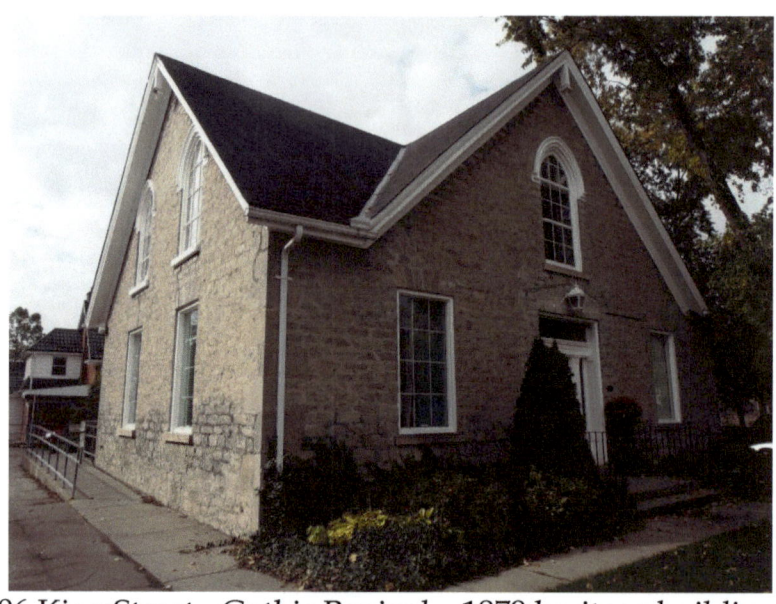

506 King Street – Gothic Revival – 1879 heritage building – cobblestone architecture

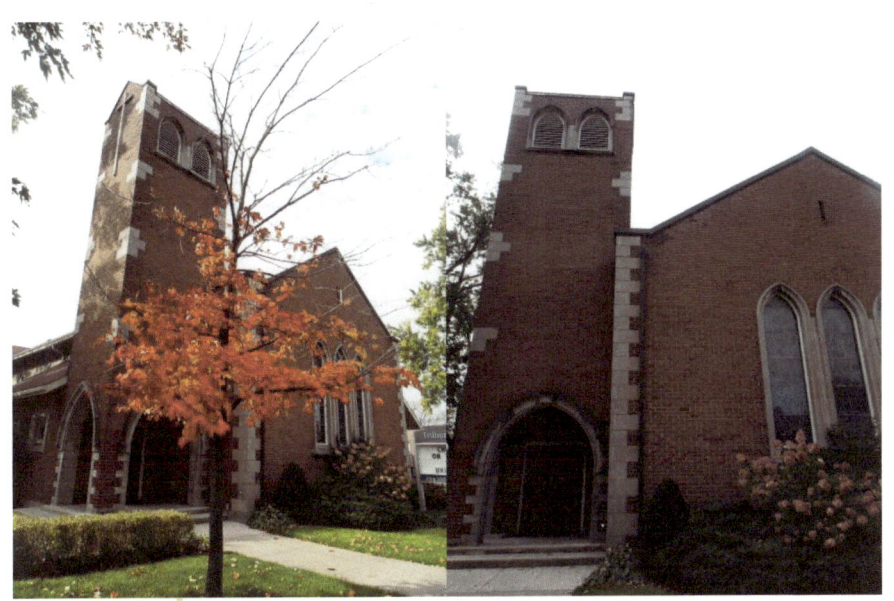

450 King Street – Trillium United Church

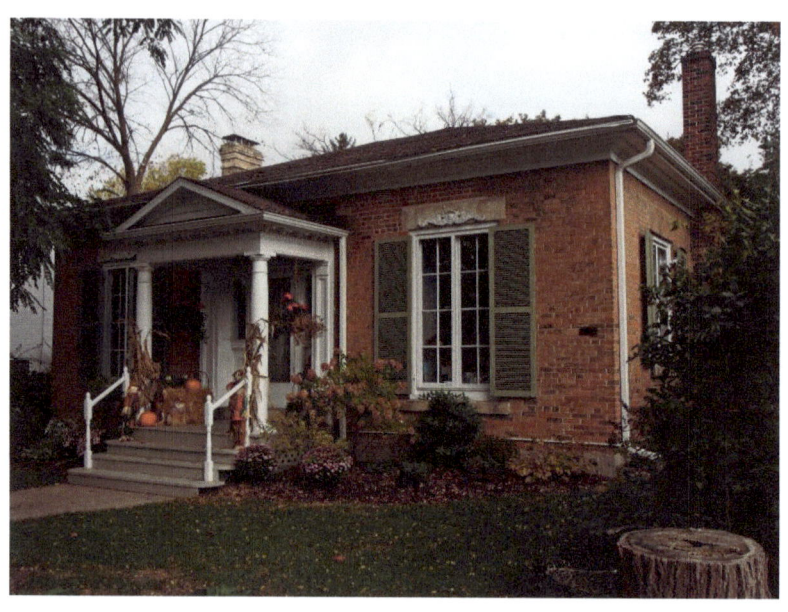

King Street – Regency Cottage – cement window hoods

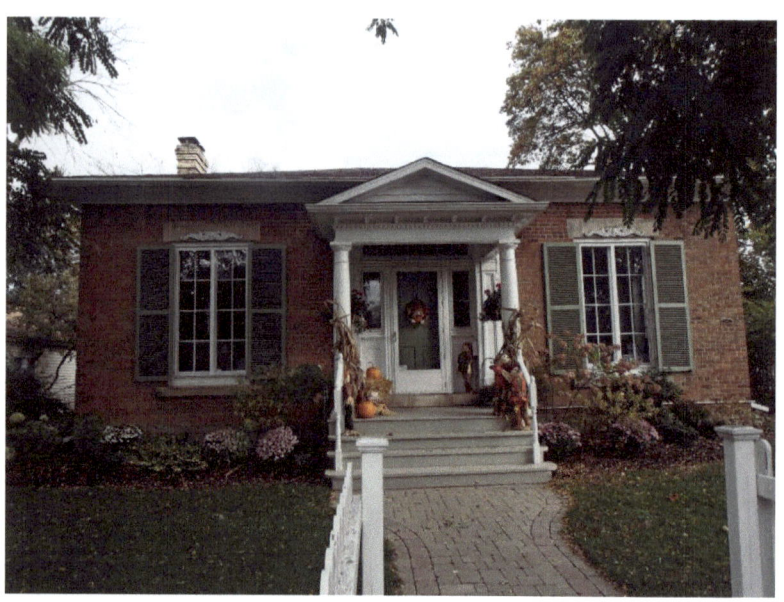

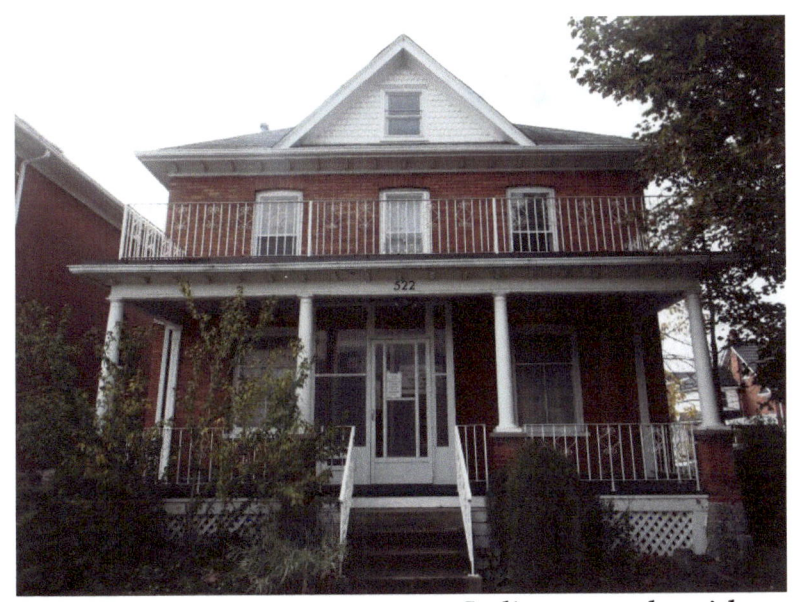

522 King Street – two storey Italianate style with dormer in attic

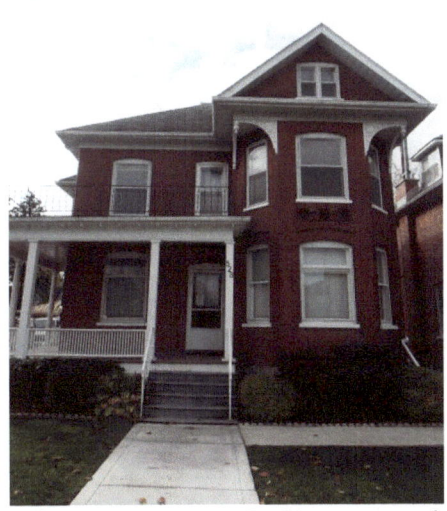

528 King Street – Italianate style
Two-and-a-half storey tower-like bay with projecting eaves and large fretwork pieces resembling brackets

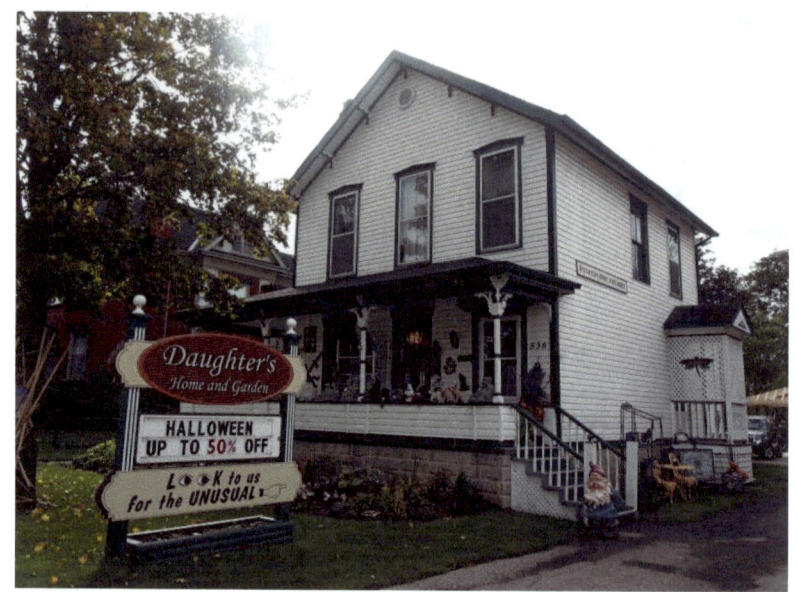

536 King Street

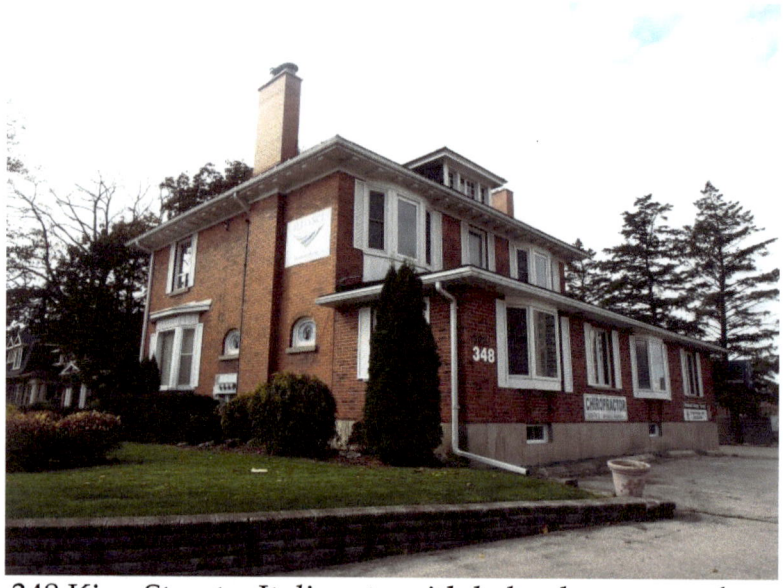

348 King Street – Italianate with belvedere on rooftop

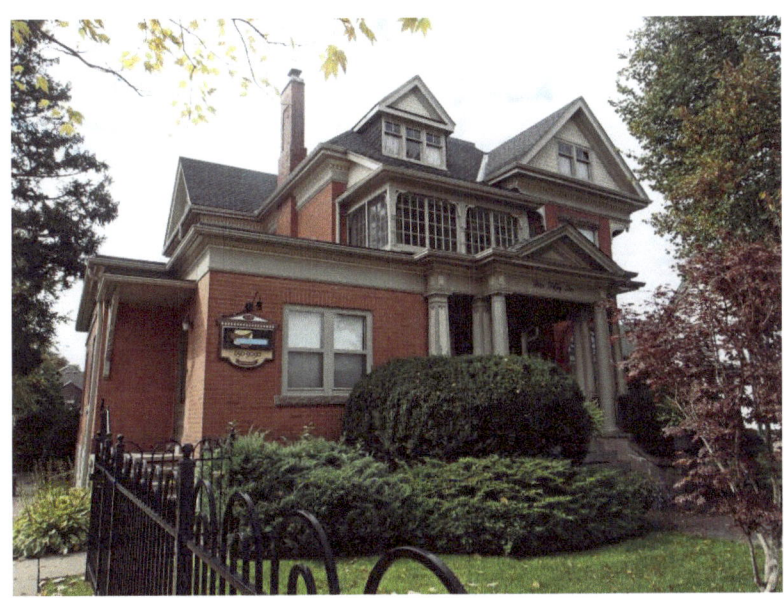

552 King Street - Italianate style
Two-and-a-half storey tower-like bays with projecting eaves
and large fretwork pieces resembling brackets

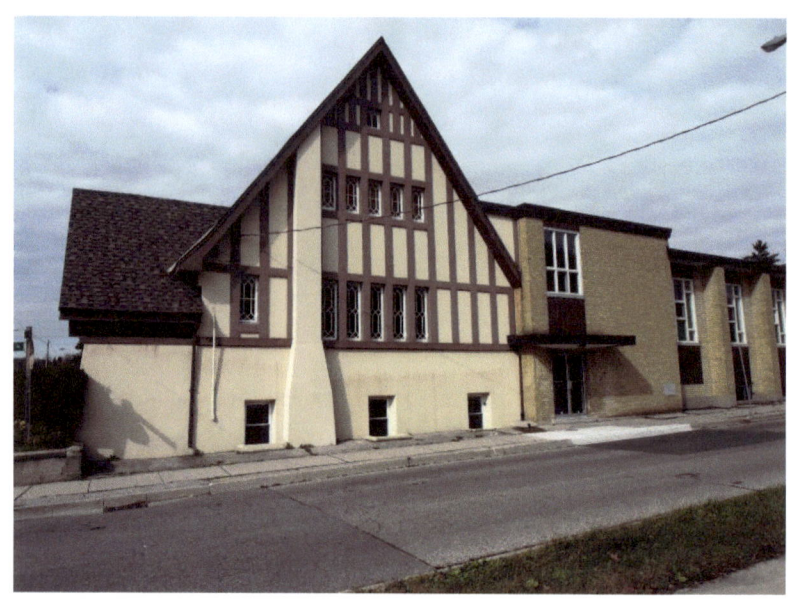

361 King Street East – King Street Baptist Church
Built 1906, renovated 1958

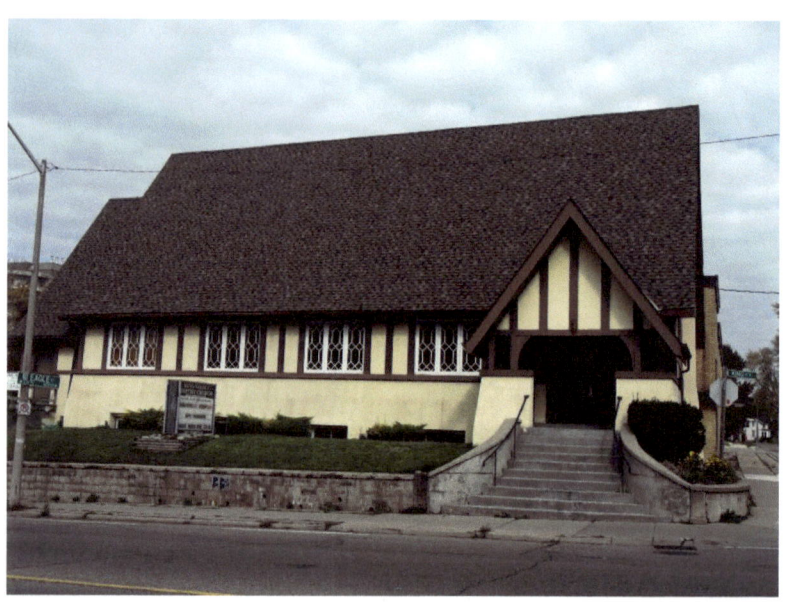

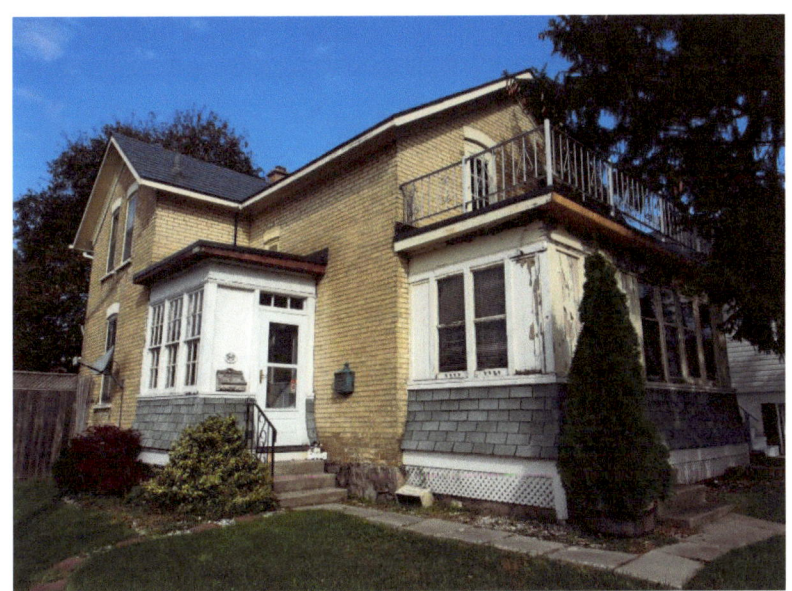

118 Montrose Street – Gothic Revival

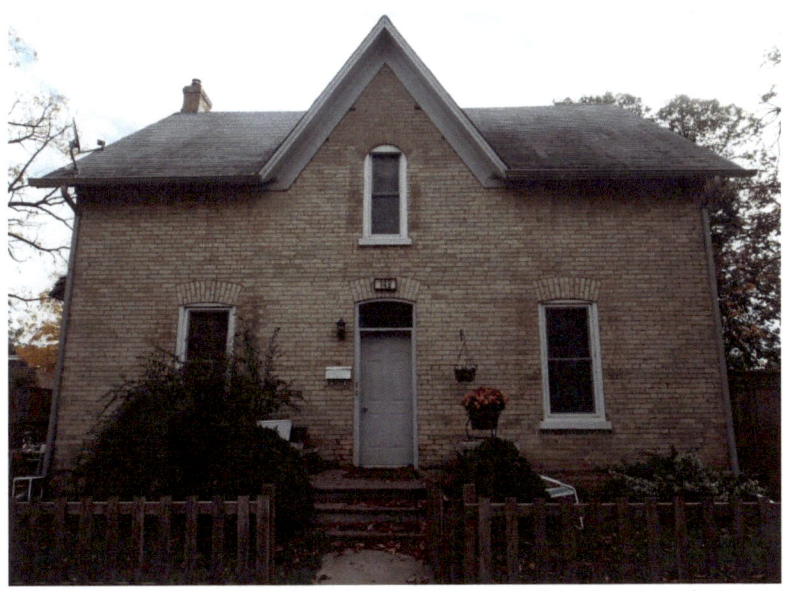

149 Argyle Street South – 1½ storey Gothic Revival Cottage

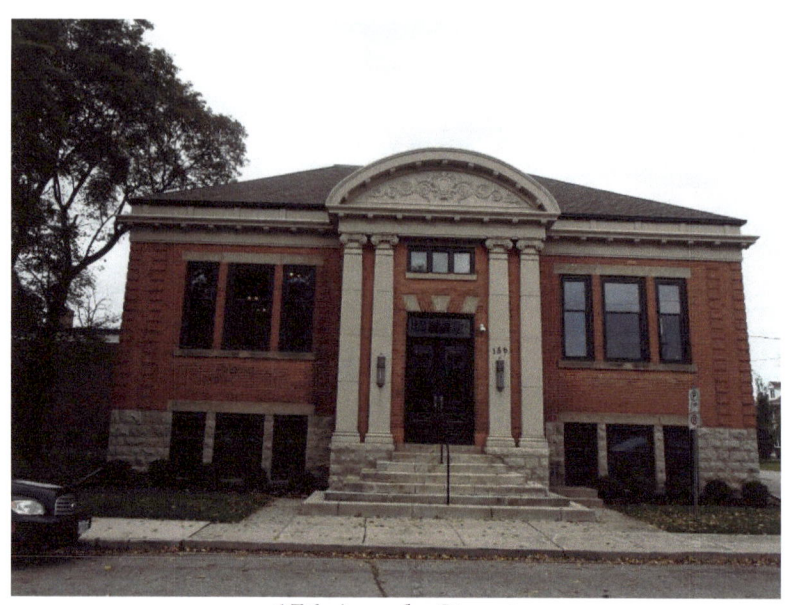

156 Argyle Street

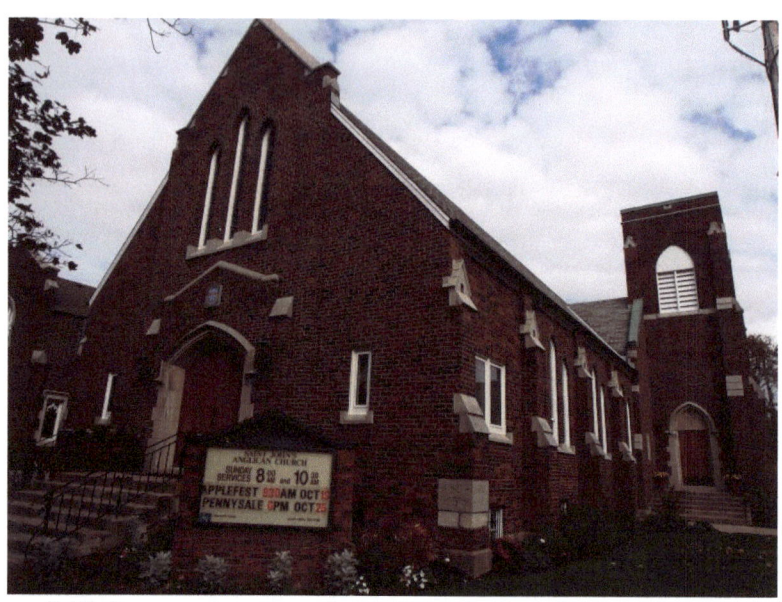

567 Queenston Road, St. John's Anglican Church

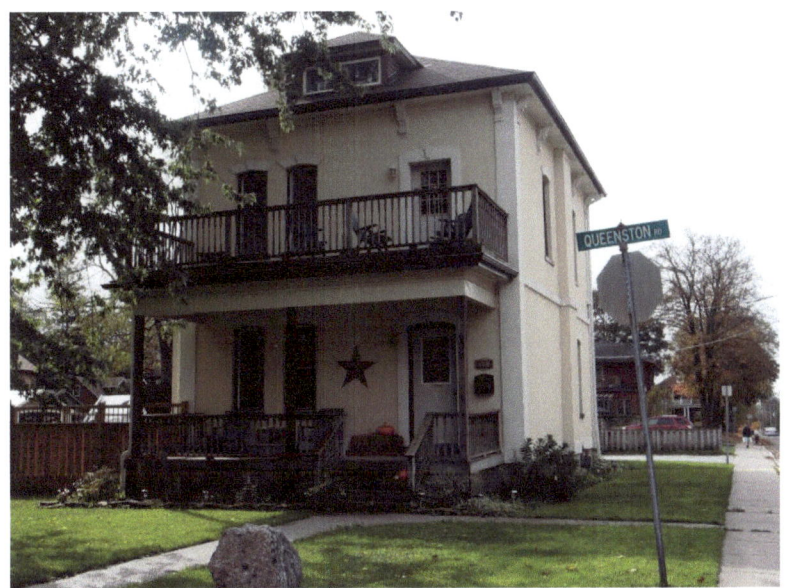

606 Queenston Road – Italianate style, dormer in attic

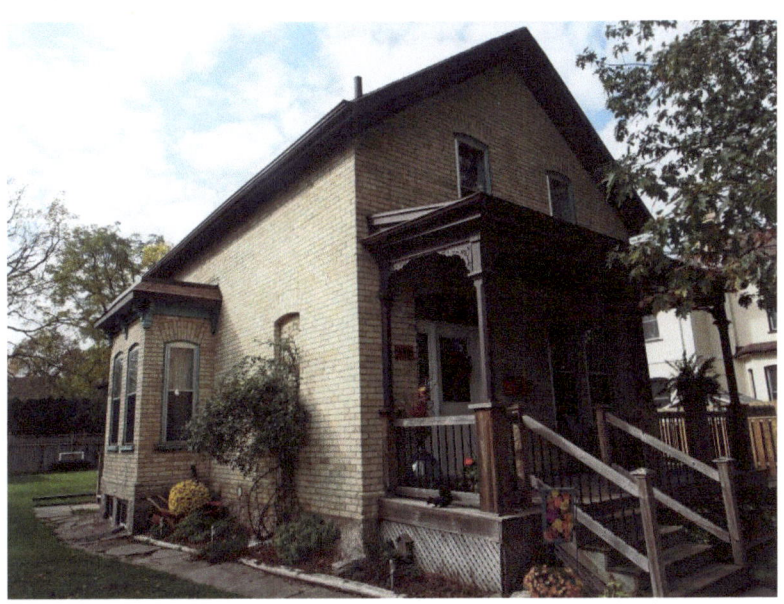

618 Queenston Road – Gothic Revival

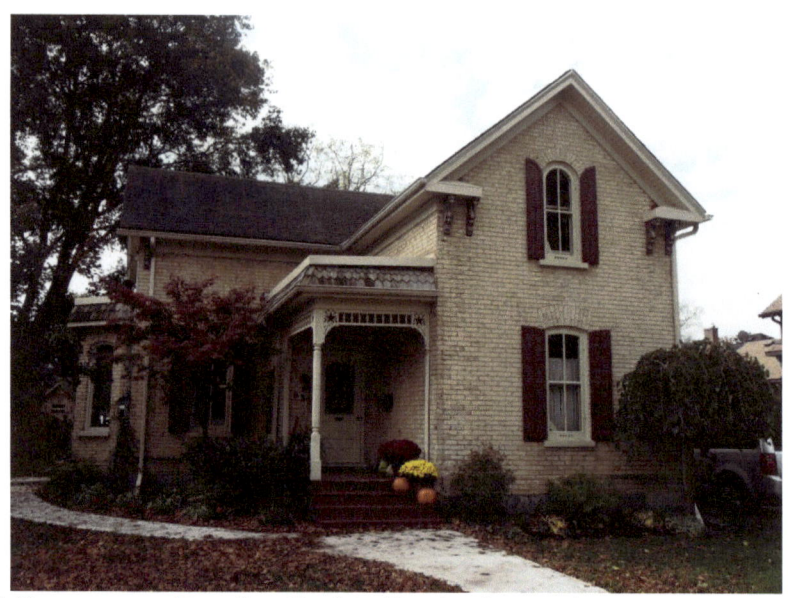

630 Queenston Road – Gothic Revival, cornice return on gable

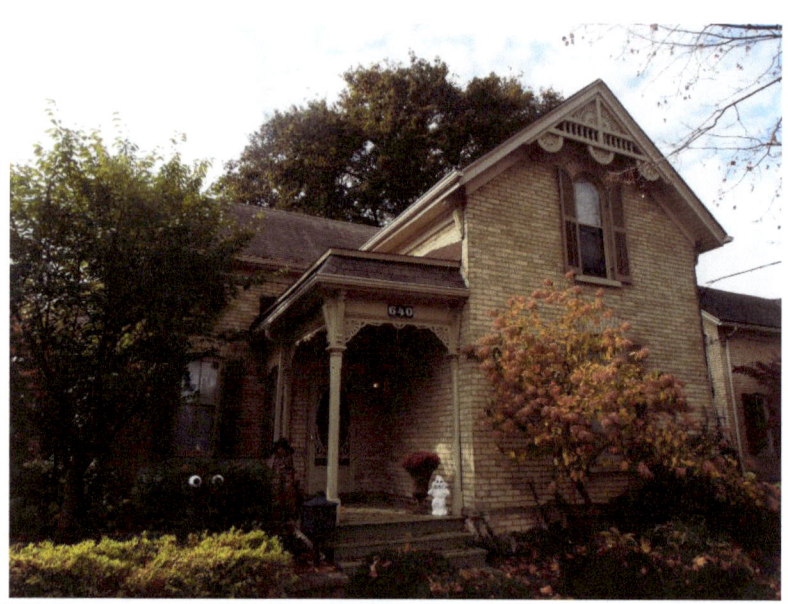

640 Queenston Road – Gothic Revival – vergeboard trim

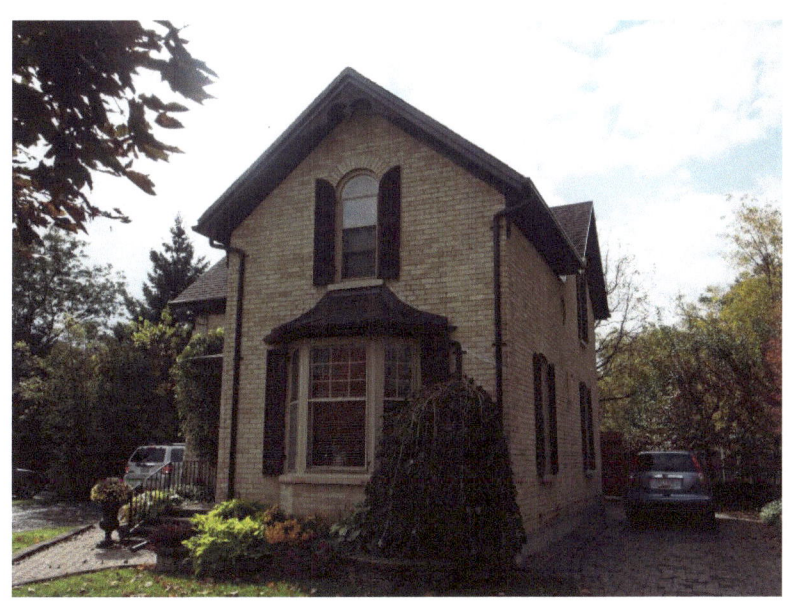

648 Queenston Road – Gothic Revival – yellow brick

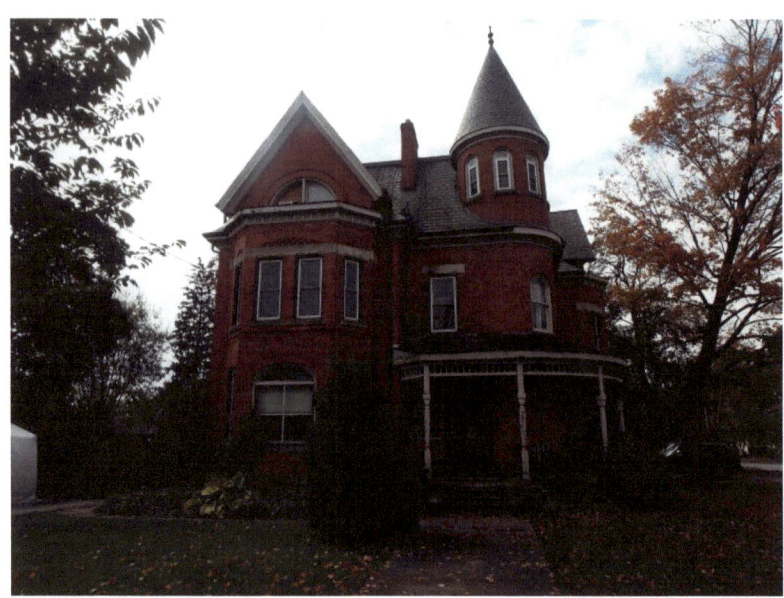

706 Queenston Road – Queen Anne style - a two-and-a-half storey tower-like bay with gable, three-storey tower with cone-shaped roof

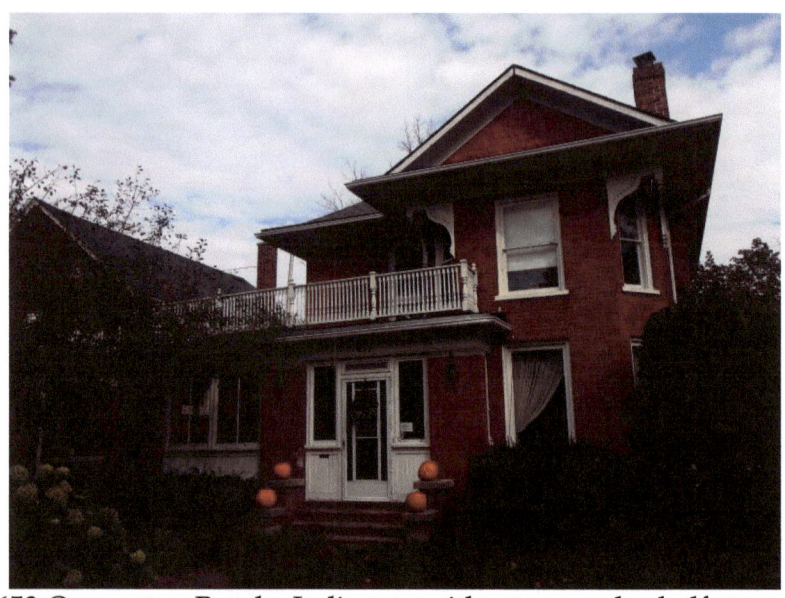

653 Queenston Road – Italianate with a two-and-a-half storey tower-like bay with projecting eaves and large fretwork pieces resembling brackets

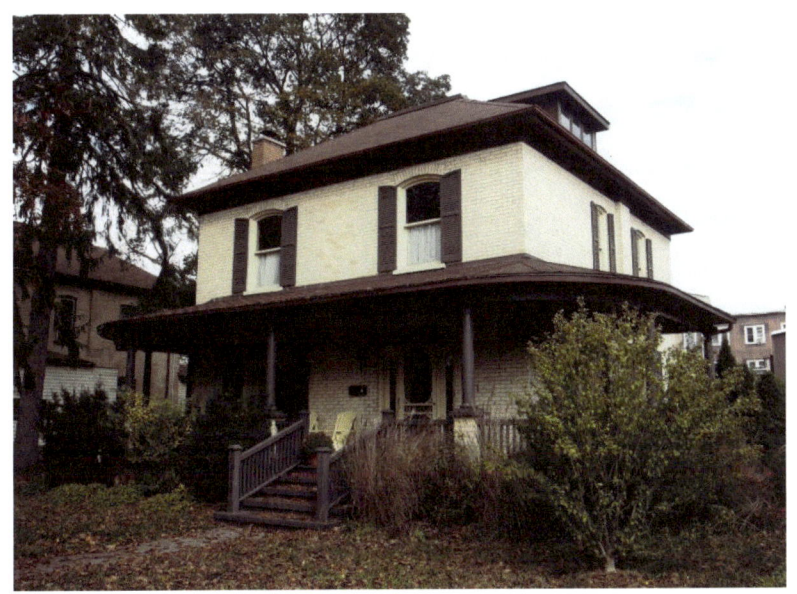

Queenston Road – yellow brick Italianate, dormer in attic

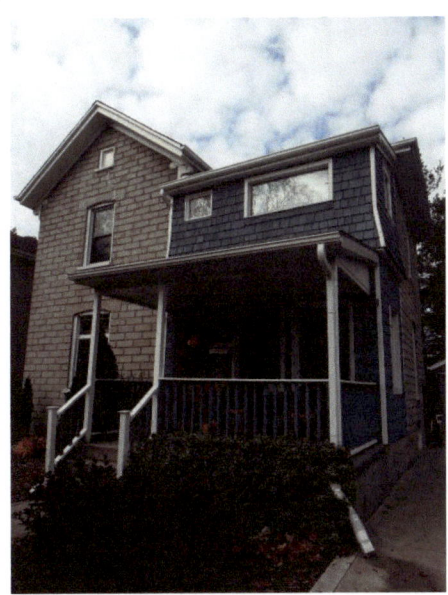

236 Queenston Road

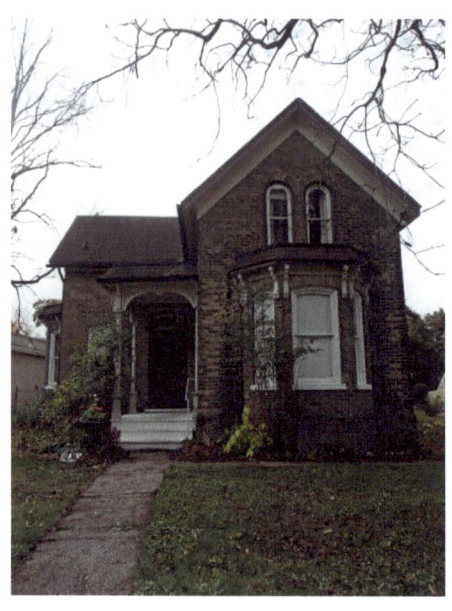

552 Queenston Road – Gothic Revival – yellow brick, cornice brackets on bay windows

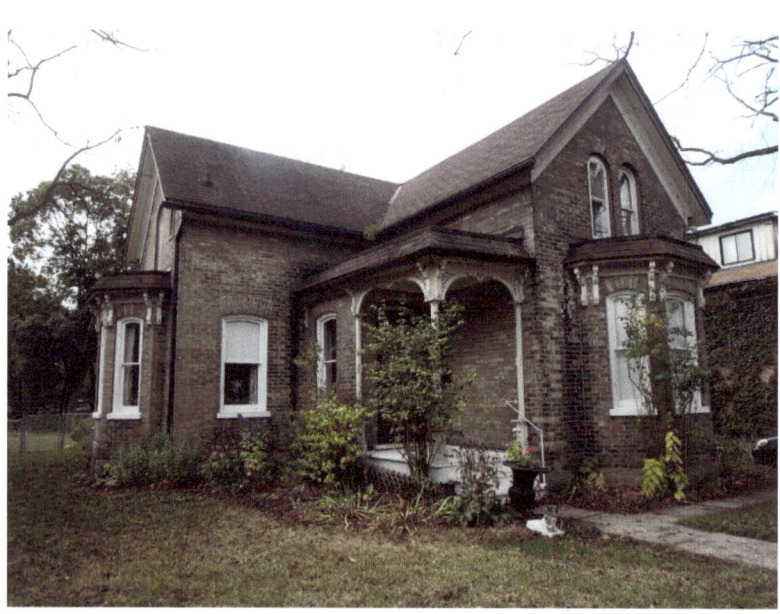

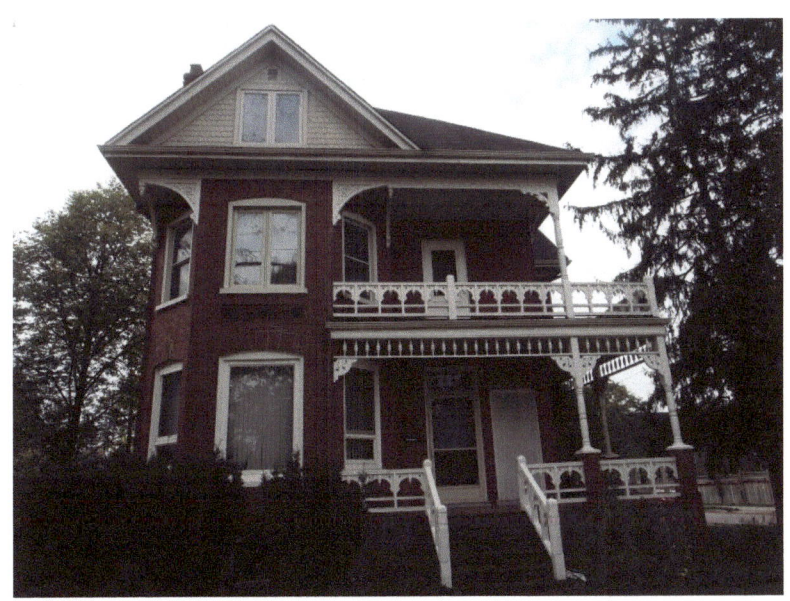

506 Queenston Road - Italianate

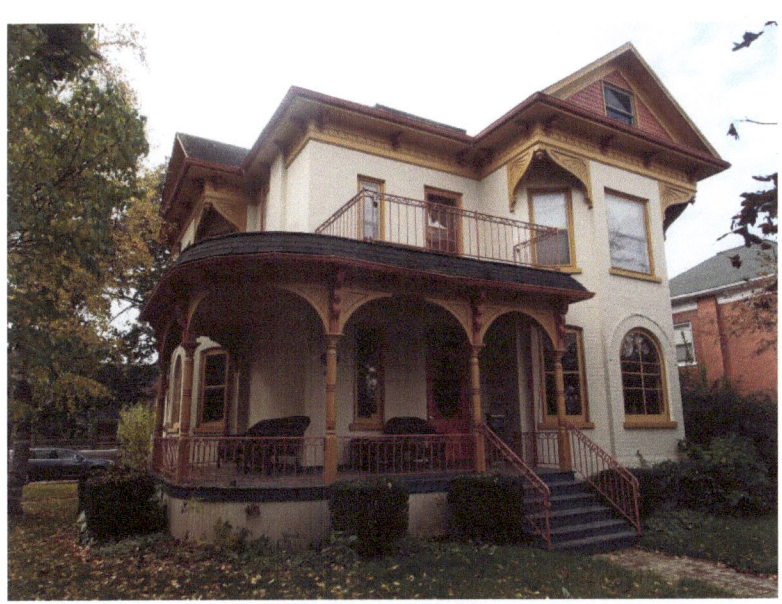

480 Queenston Road – Italianate with a two-and-a-half storey tower-like bay with projecting eaves and large fretwork pieces resembling brackets

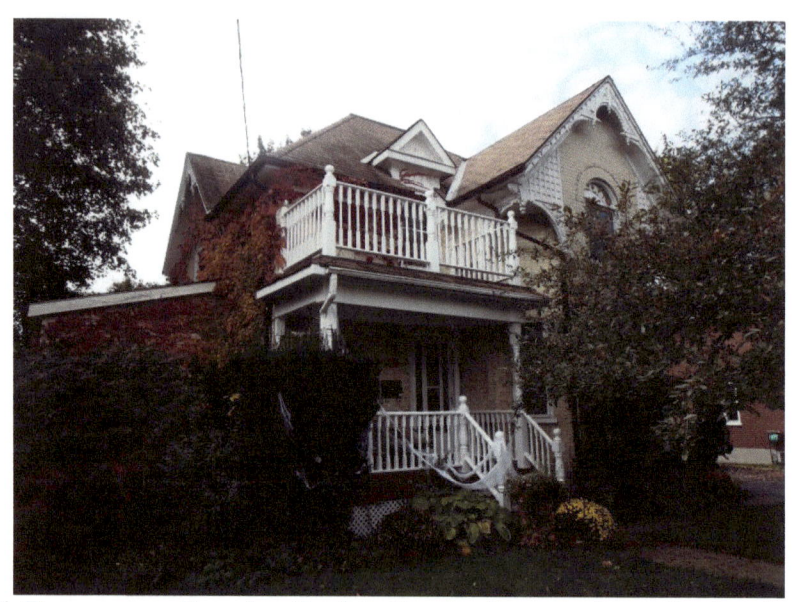

446 Queenston Road – Gothic Revival, vergeboard trim, large fretwork pieces resembling brackets

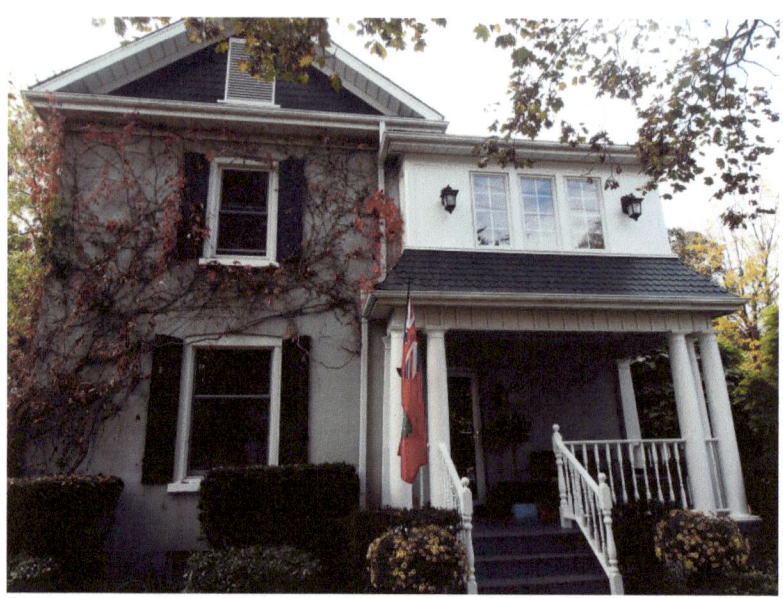

406 Queenston Road – Italianate style

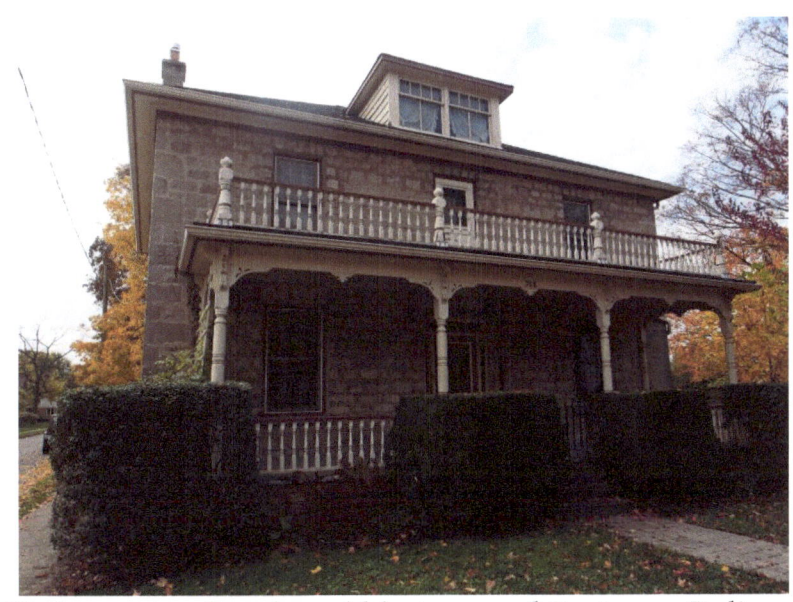

358 Queenston Road – cobblestone architecture – Italianate style, dormer in attic

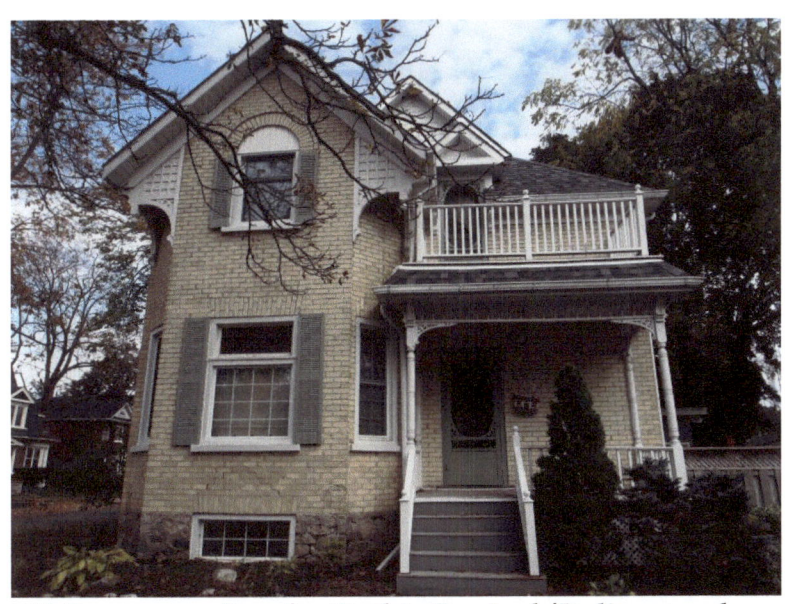

407 Queenston Road – Gothic Revival/Italianate - large fretwork pieces resembling brackets, balcony on second floor

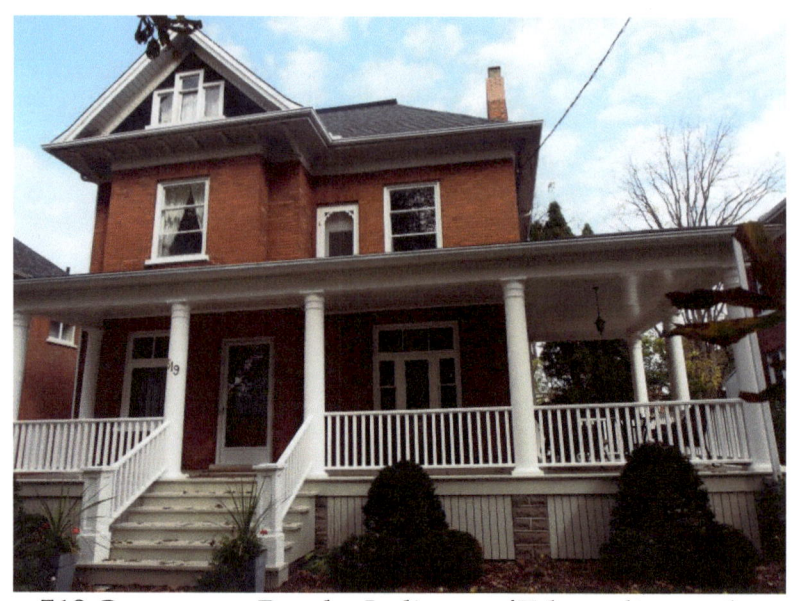

519 Queenston Road – Italianate/Edwardian style, Palladian window in gable

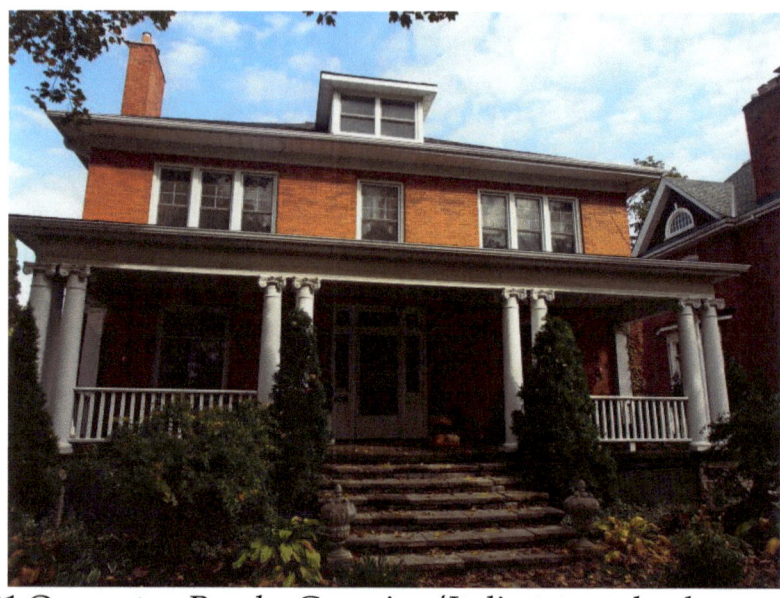

531 Queenston Road – Georgian/Italianate style, dormer in attic, pillars with capitals

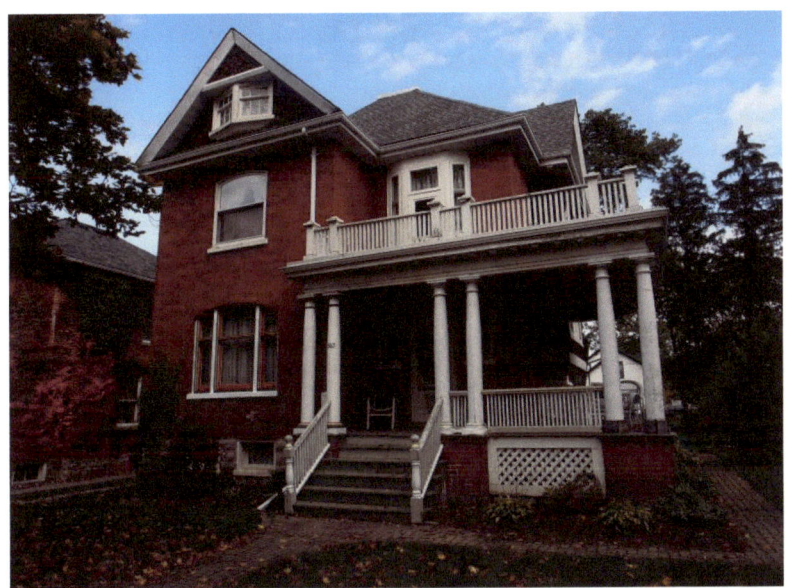

543 Queenston Road – Italianate/Edwardian style

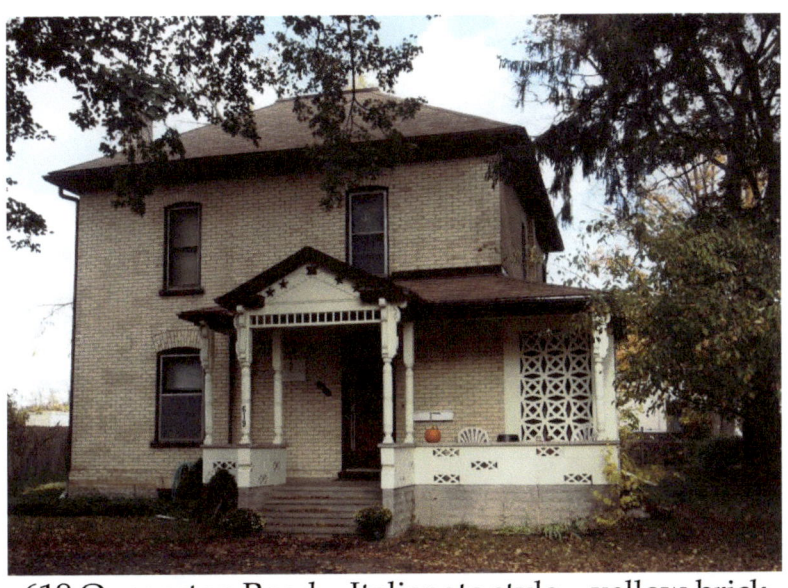

619 Queenston Road – Italianate style – yellow brick

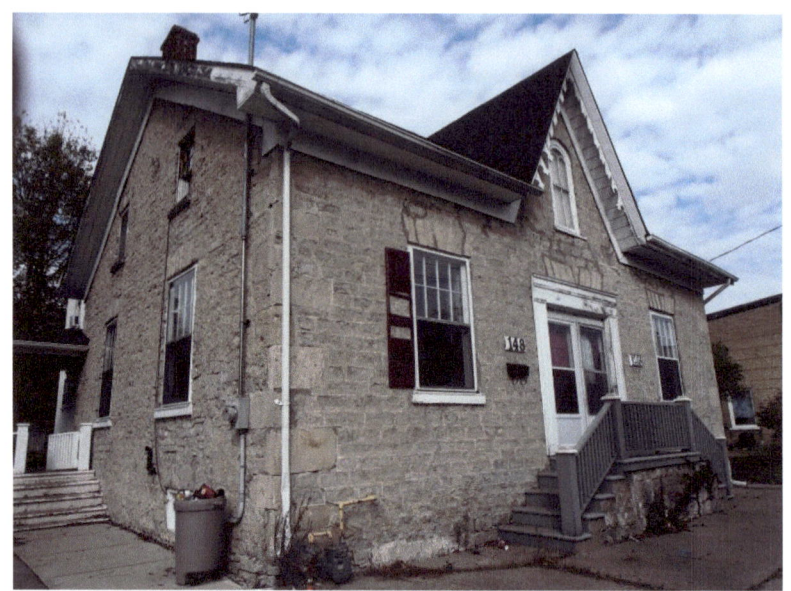
148 Westminster Drive South – Gothic Revival cobblestone

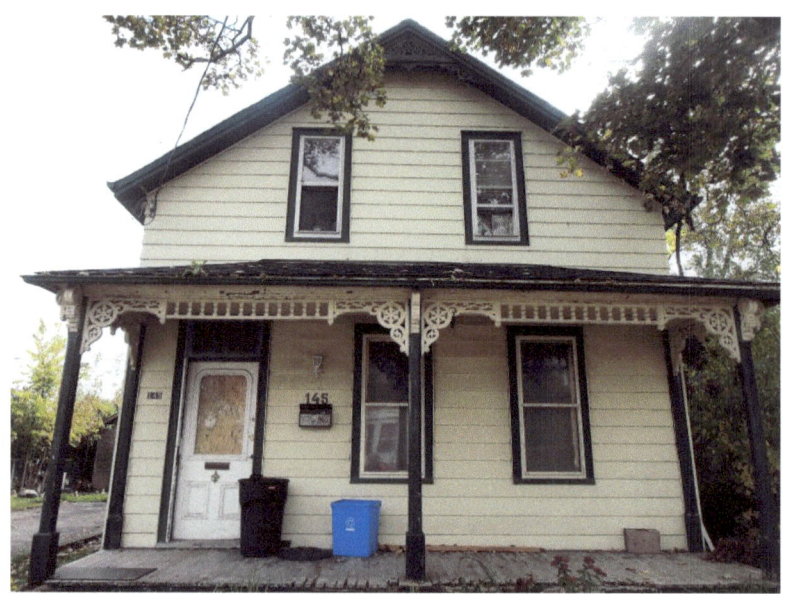
145 Westminster Drive South – Gothic Revival

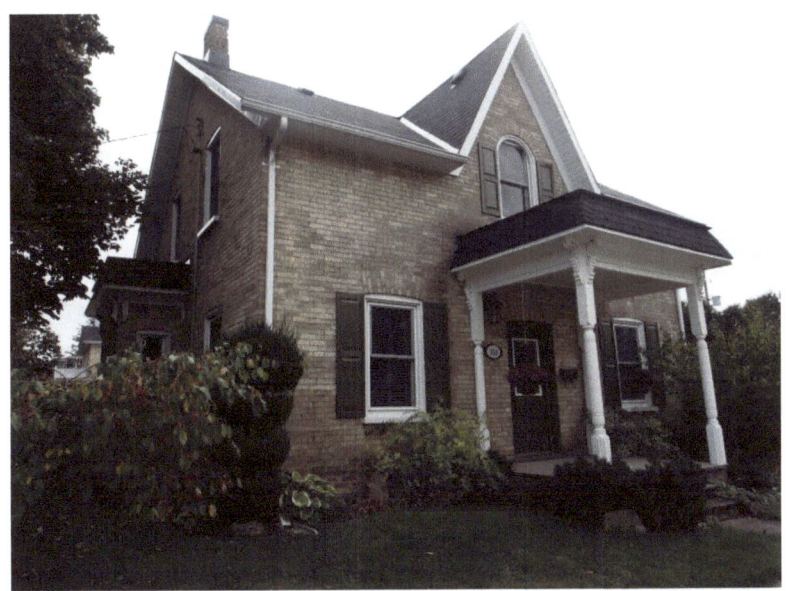

153 Duke Street – 1½ storey Gothic Revival in yellow brick

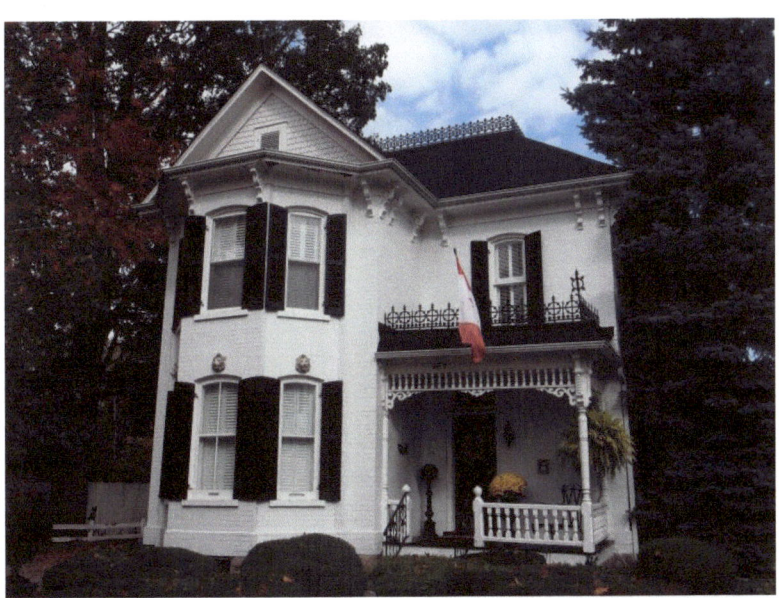

469 Duke Street – Italianate with two-and-a-half-storey tower-like bay topped with triangular pediment; iron cresting on roof top and around second floor balcony

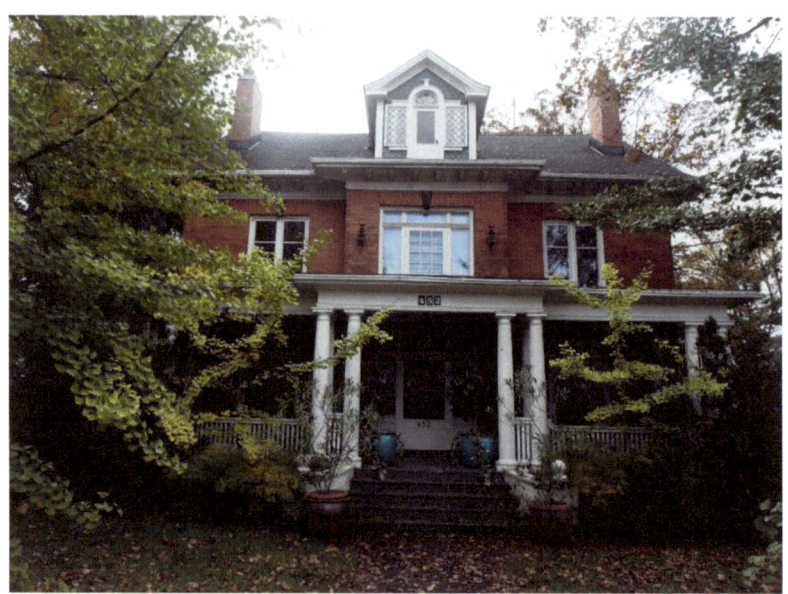

452 Duke Street – Italianate style with dormer in attic

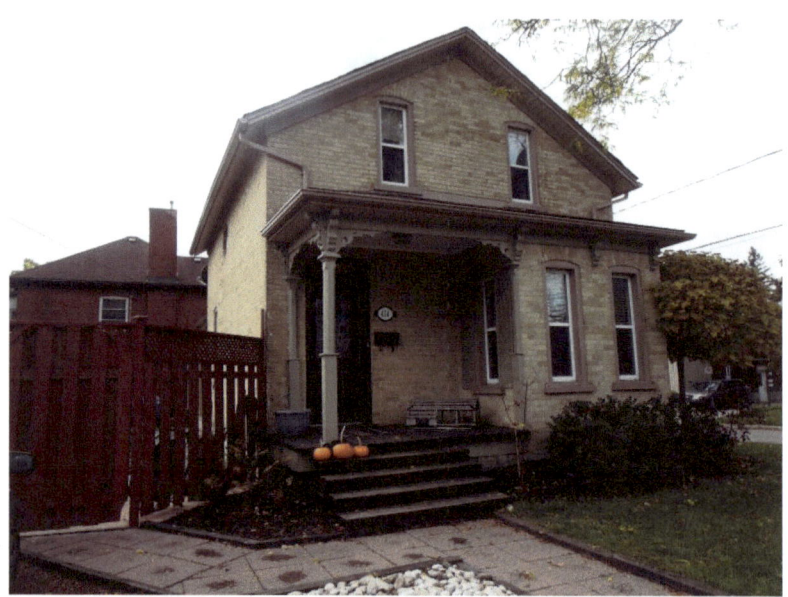

415 Duke Street – Gothic Revival in yellow brick

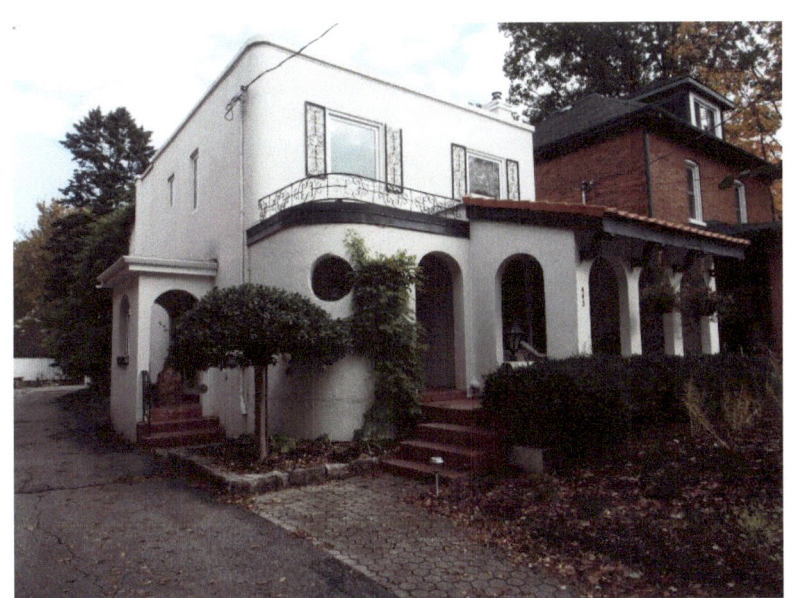

443 Duke Street – Art Moderne style

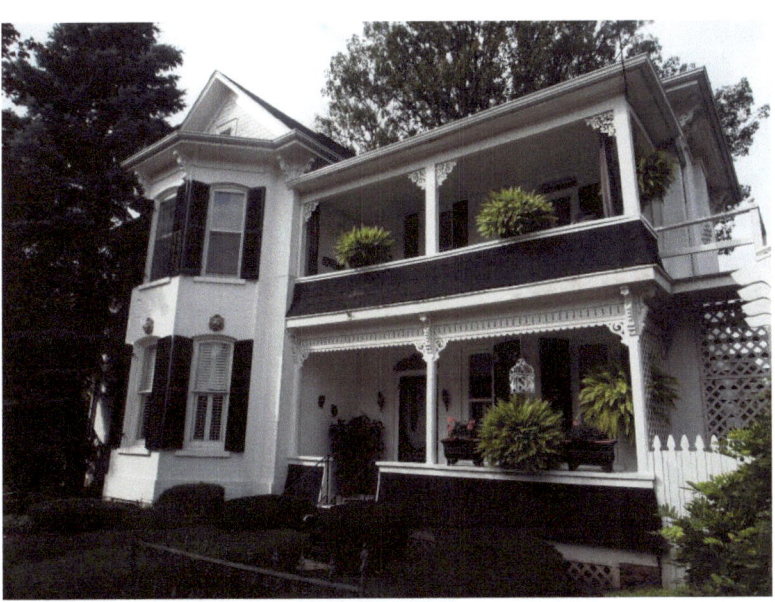

Duke Street – Italianate with two-and-a-half-storey tower-like bay topped with triangular pediment; verandahs on first and second floors

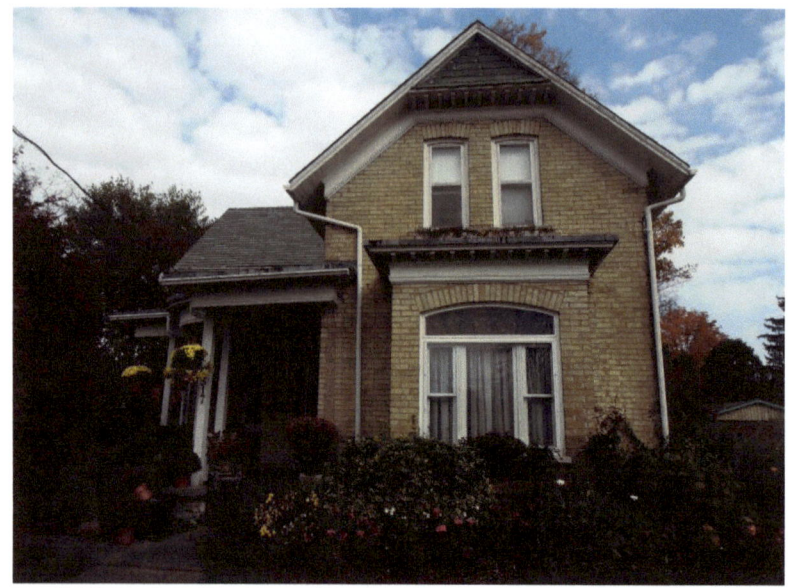

517 Duke Street – Gothic Revival in yellow brick

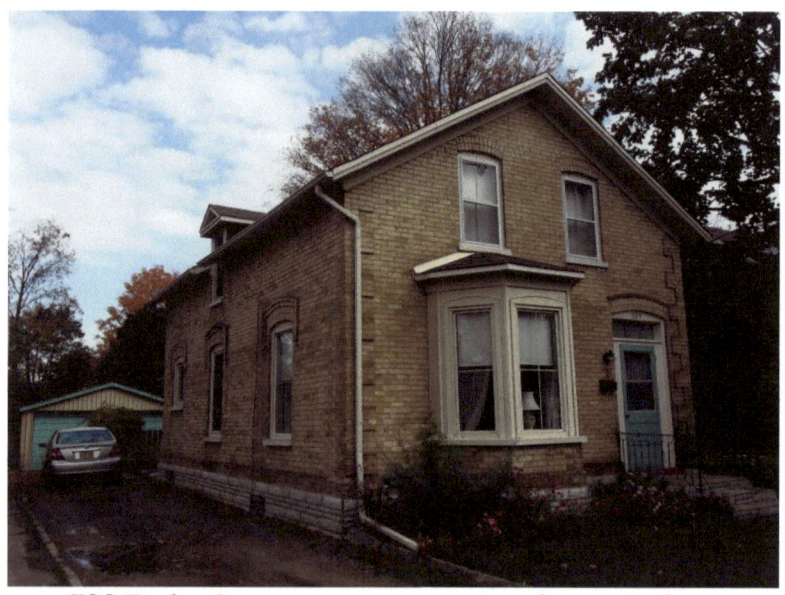

529 Duke Street – corner quoins, bay window

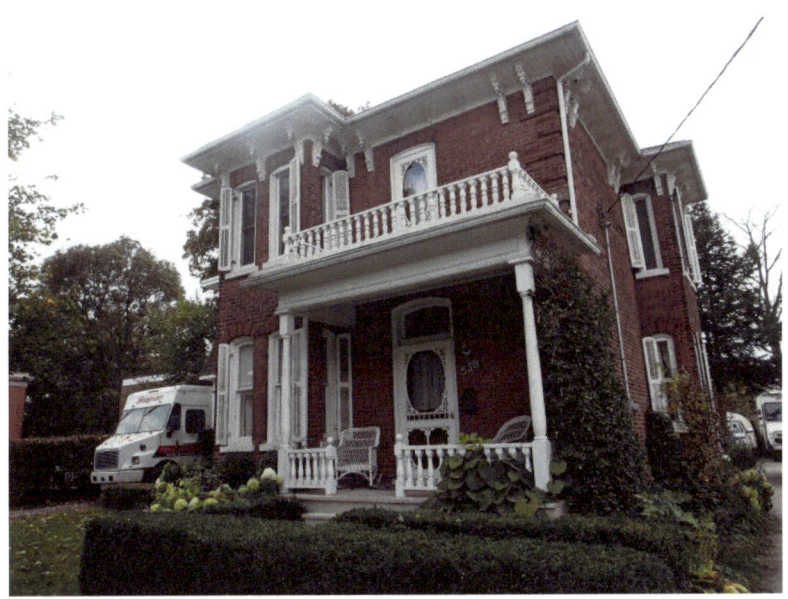

533 Duke Street – Italianate, two-storey tower like bays on front and side of house, balcony on second floor

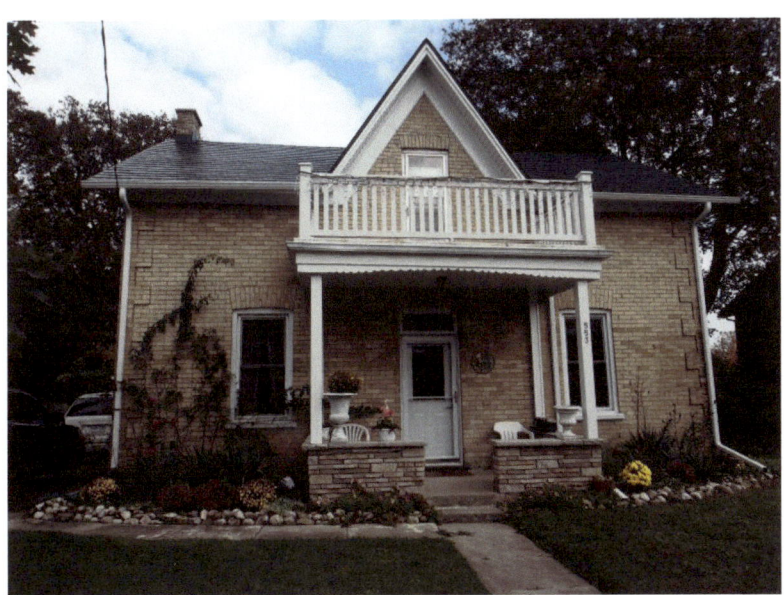

553 Duke Street – Gothic Revival cottage, corner quoins, balcony on second floor

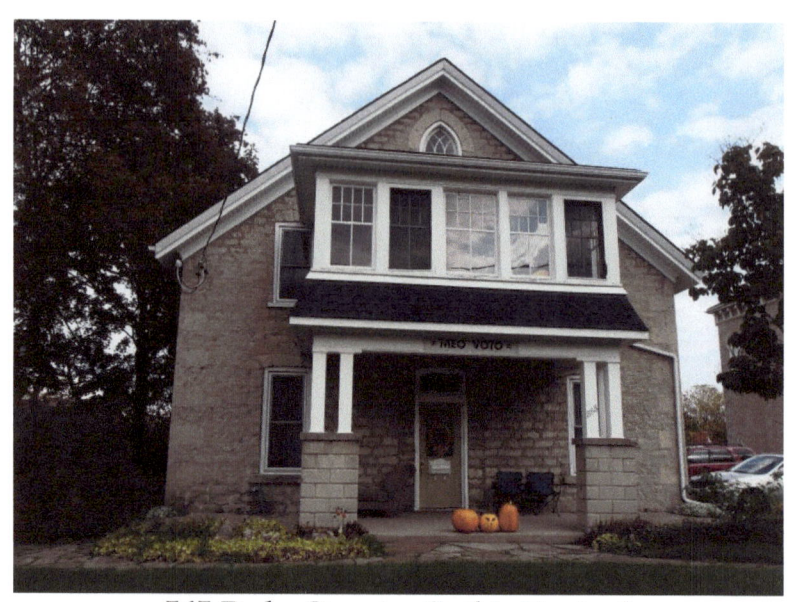

565 Duke Street – Gothic Revival
with second floor sunroom addition

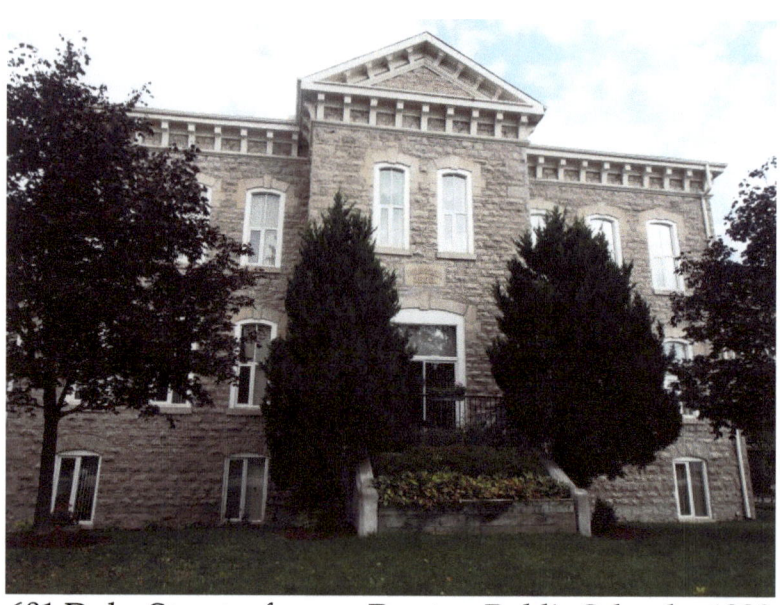

601 Duke Street – former Preston Public School – 1889
Now Preston School Apartments

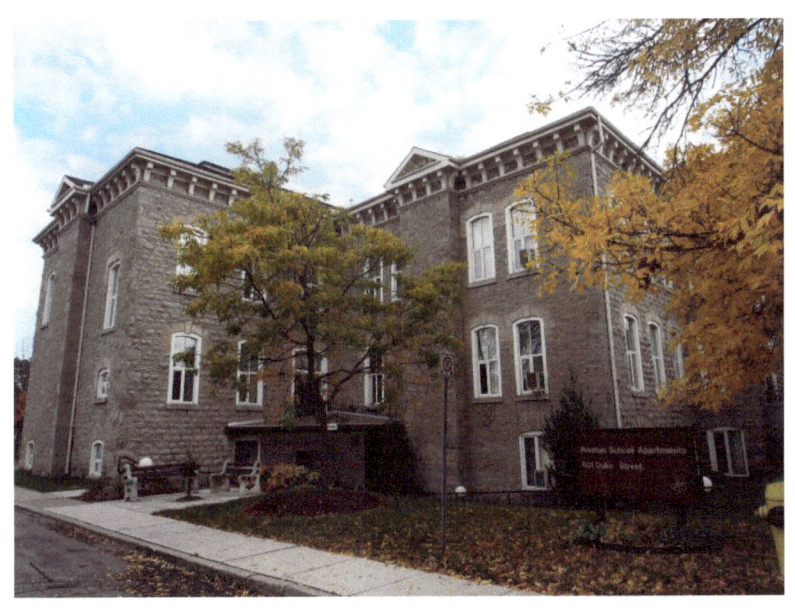

Preston School Apartments

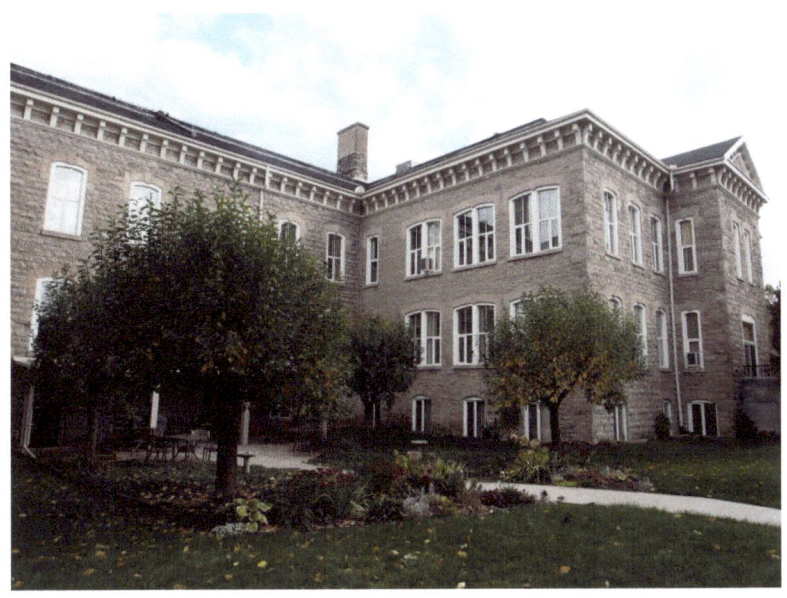

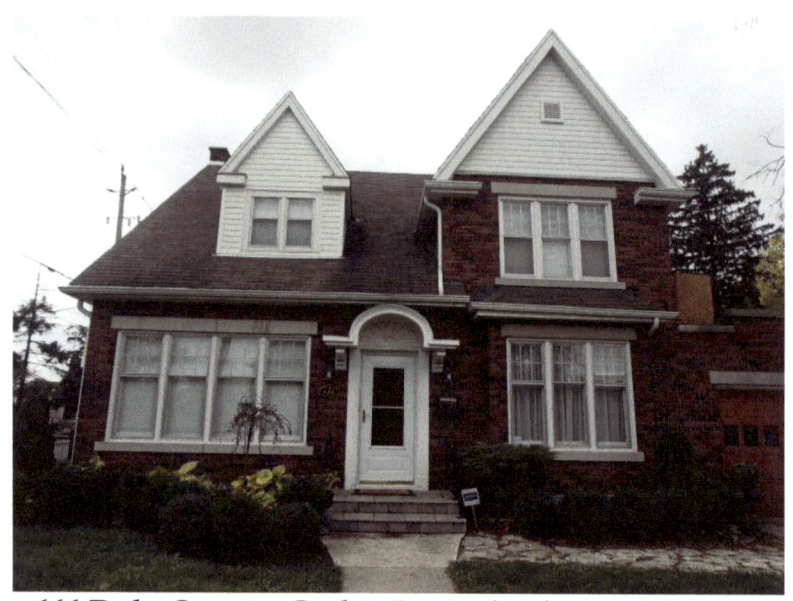

666 Duke Street – Gothic Revival – dormers in attic, cornice return on gables

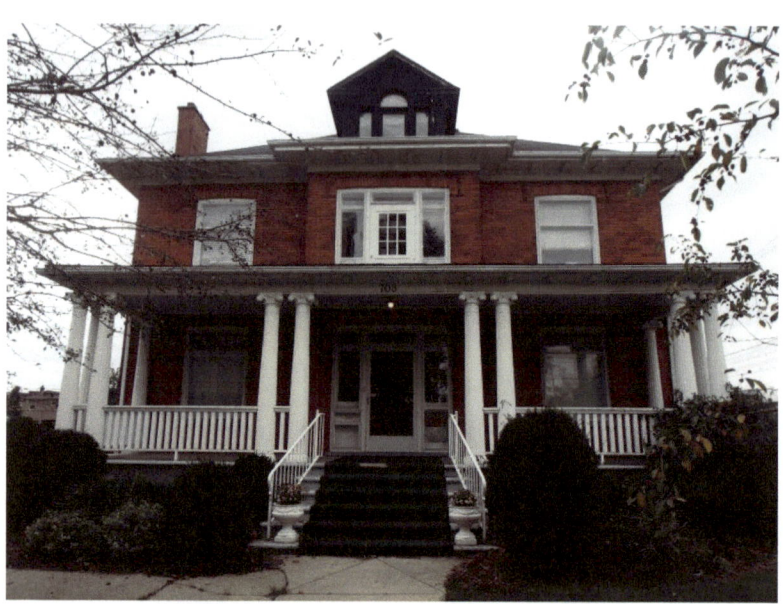

708 Duke Street – Italianate style with belvedere-like dormer in attic

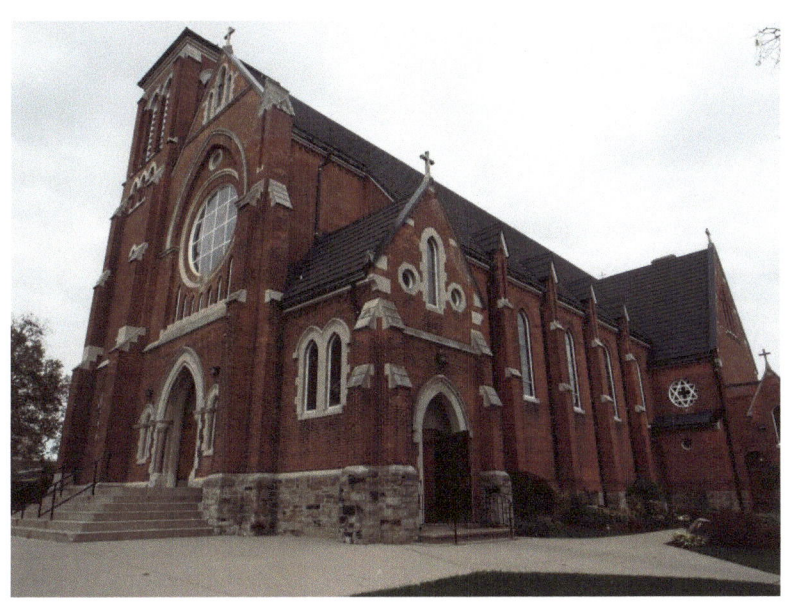

745 Duke Street – St. Clements Catholic Church

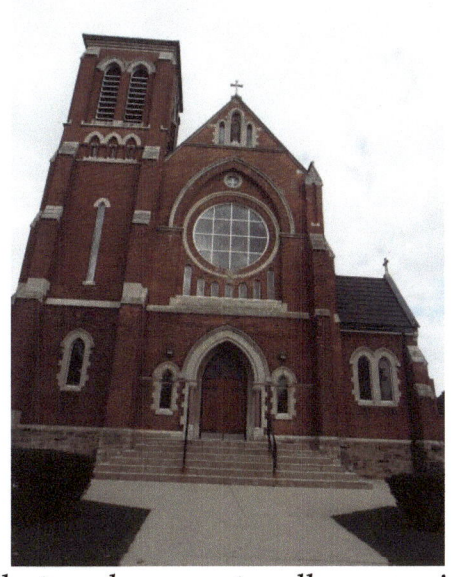

Cobblestone basement walls, rose window

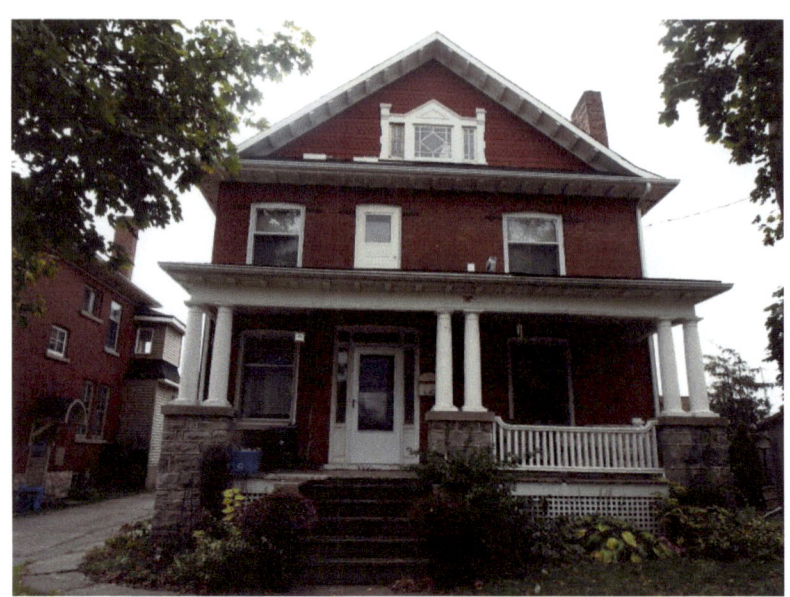

722 Duke Street – Edwardian style

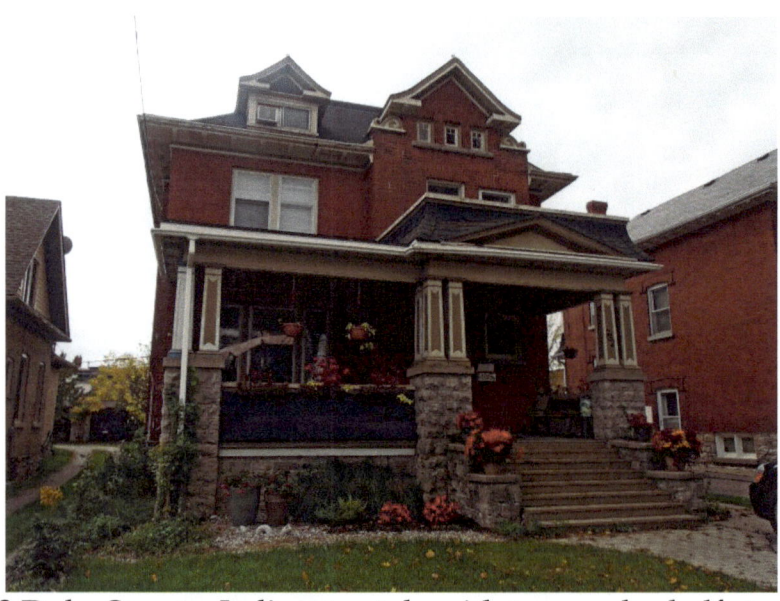

732 Duke Street – Italianate style with two-and-a-half storey tower-like bay with cornice return on gable; dormer in attic

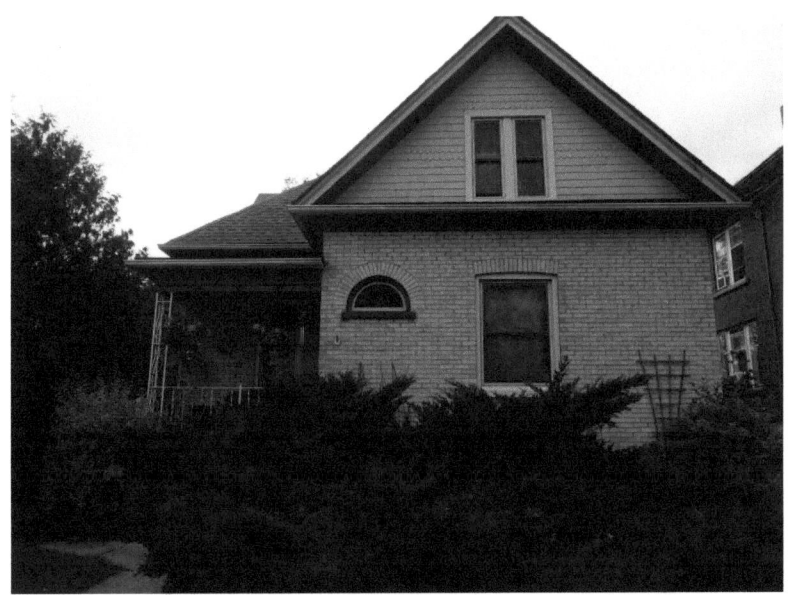

742 Duke Street – yellow brick – Gothic Revival

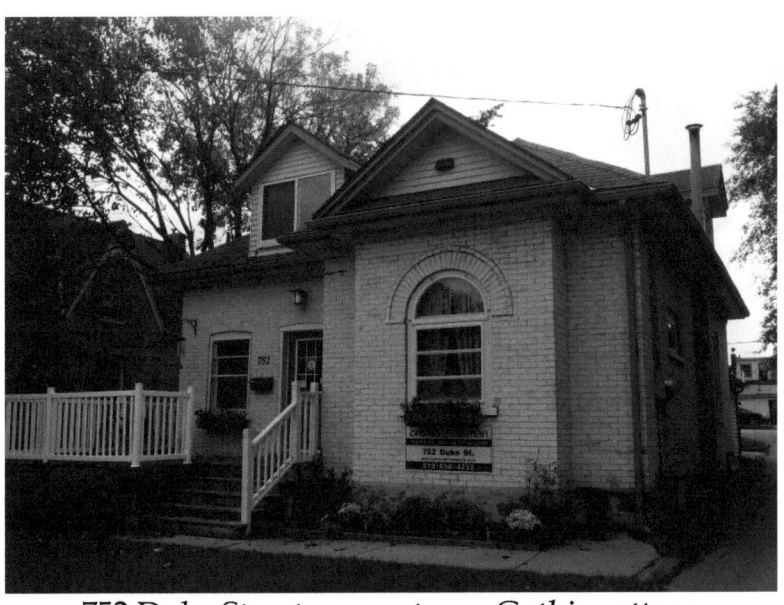

752 Duke Street – one-storey Gothic cottage with dormer in attic

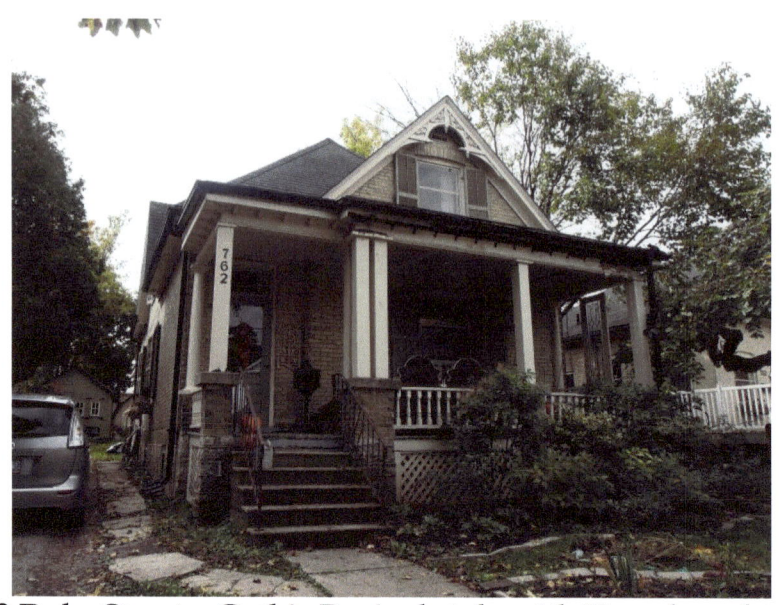

762 Duke Street – Gothic Revival style with Vergeboard trim on gable – yellow brick

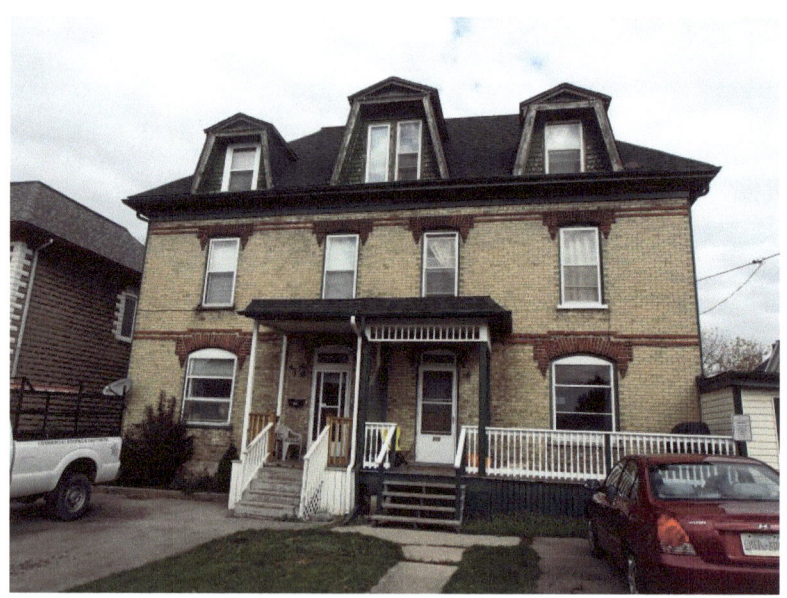

973-975 Duke Street – yellow brick – dormers in attic

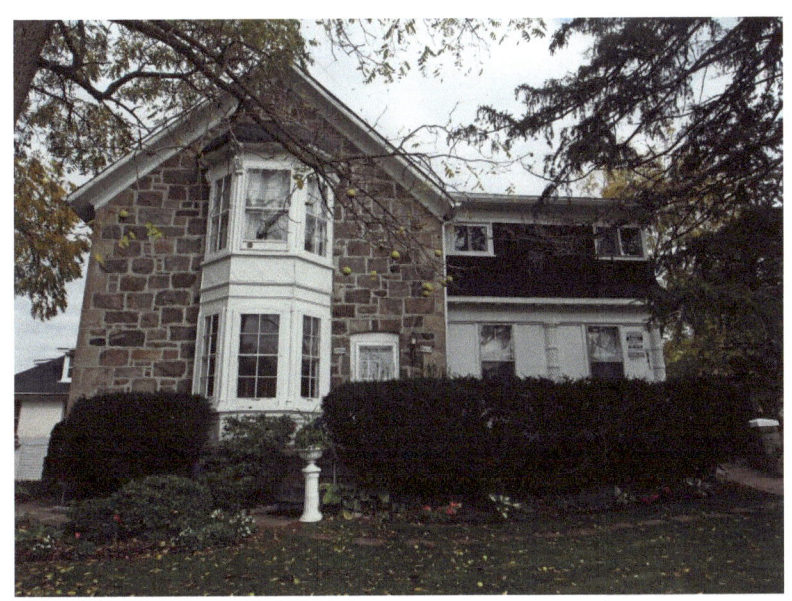

939-941 Duke Street – cobblestone architecture, two-storey bay window

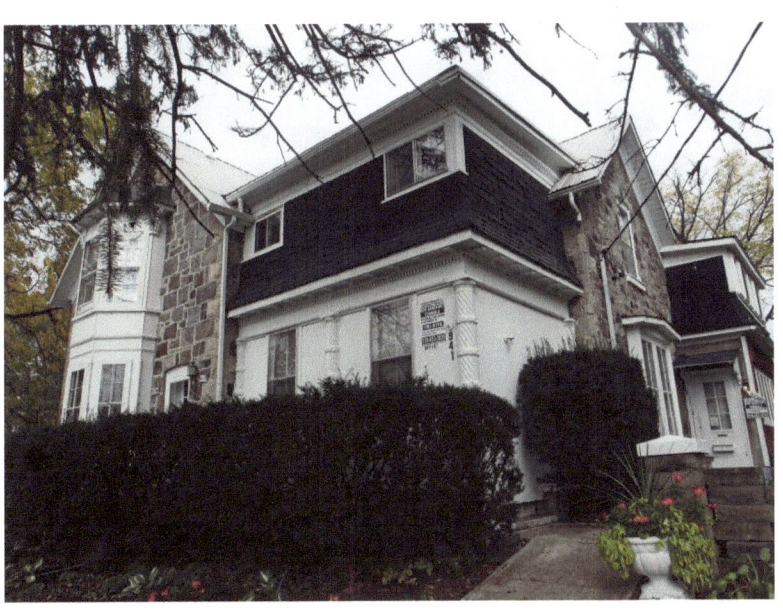

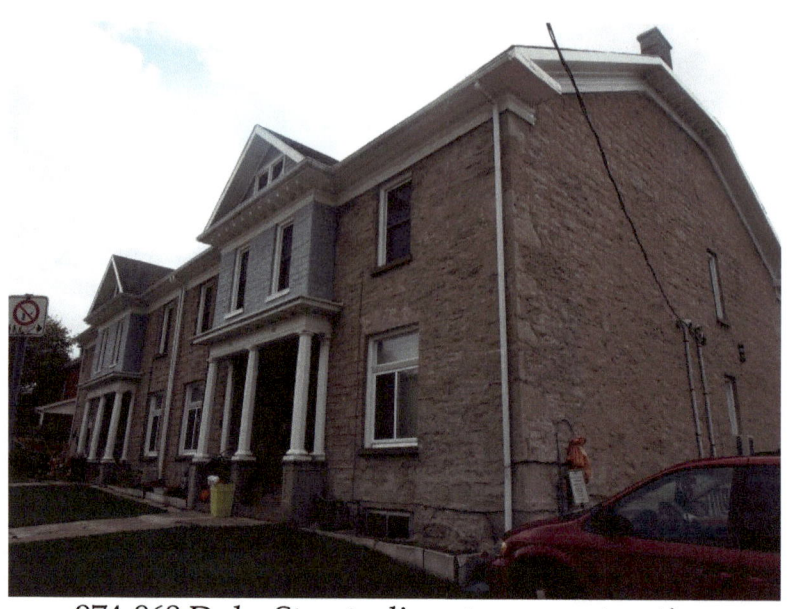

974-968 Duke Street – limestone construction

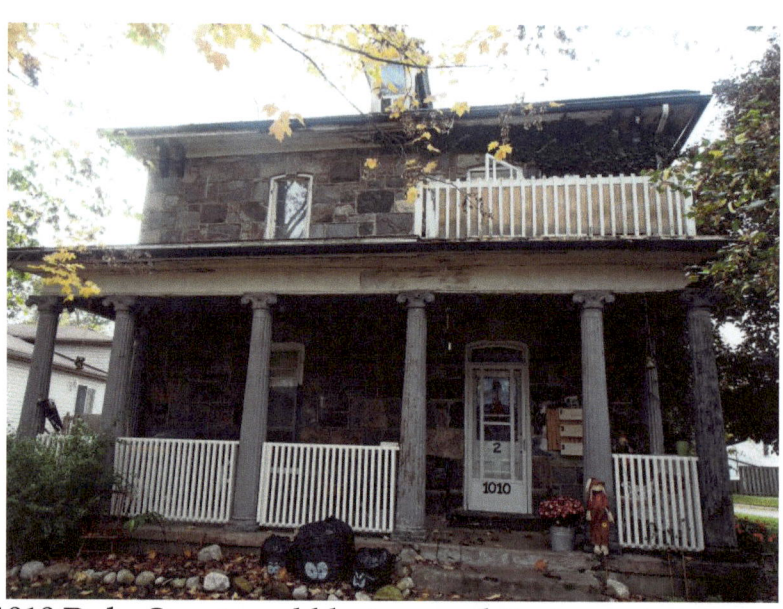

1010 Duke Street – cobblestone architecture – two-storey Italianate style, paired cornice brackets, decorative capitals on pillars

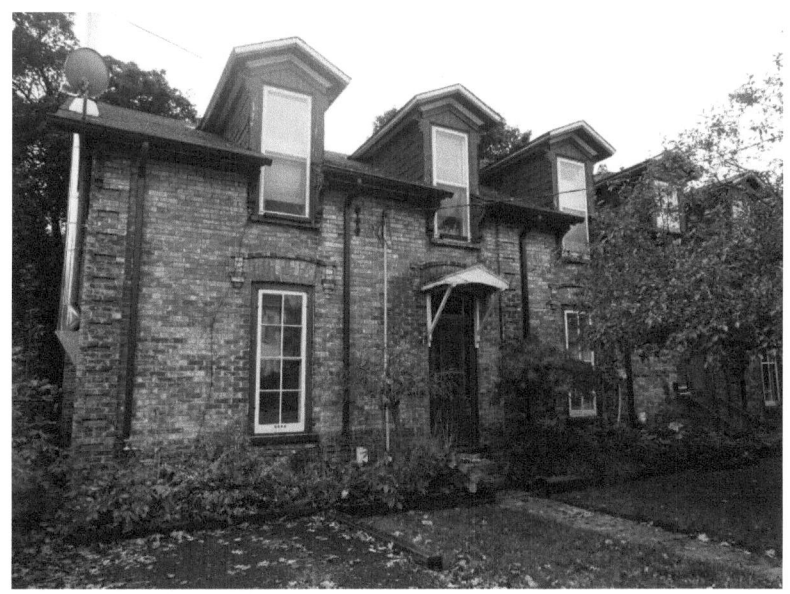

Duke Street – yellow brick, dormers in attic

1106 Duke Street – Edwardian style

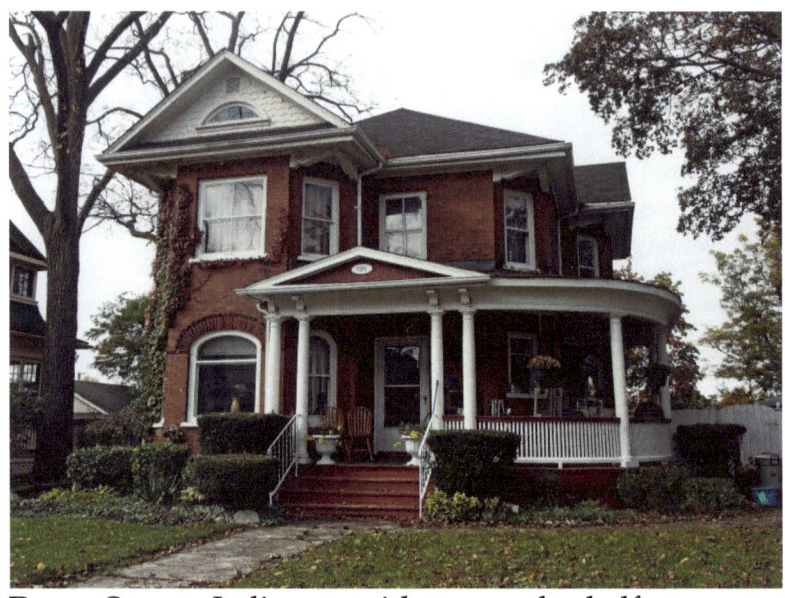

126 Dover Street - Italianate with two-and-a-half-storey tower-like bay topped with triangular gable

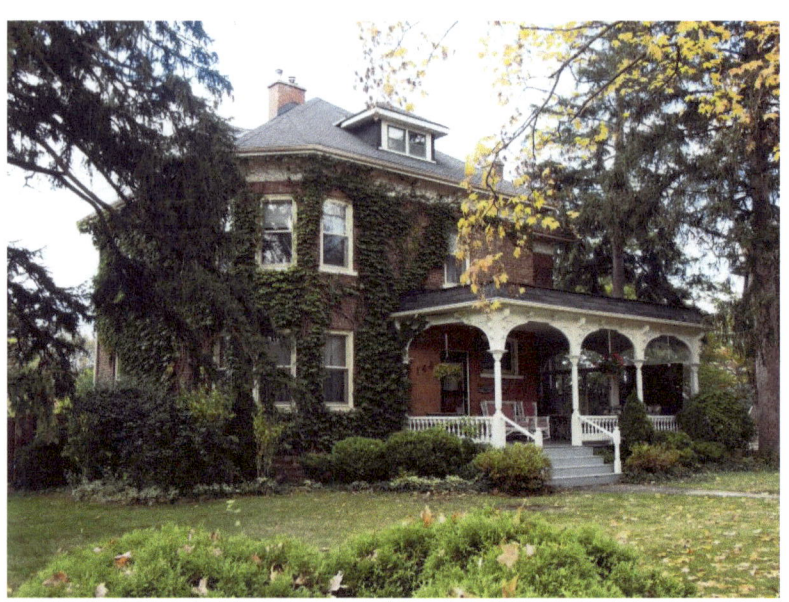

148 Dover Street – two-storey Italianate style, hipped roof, dormer in attic

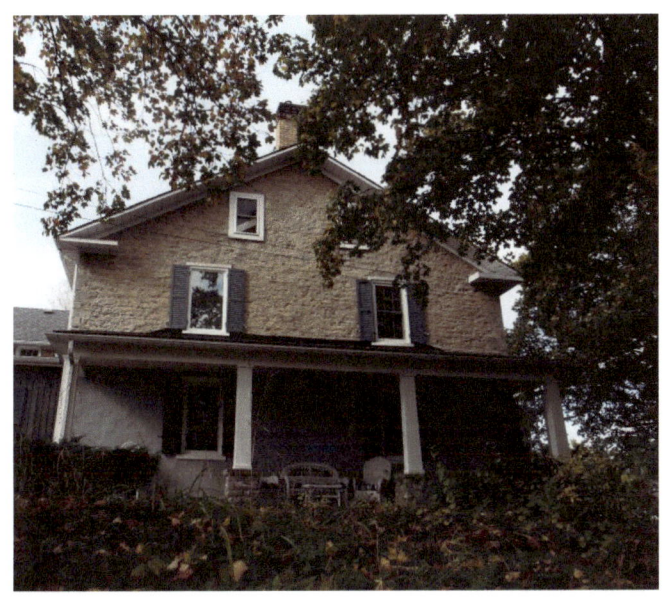

2162 Coronation Boulevard – Gothic Revival

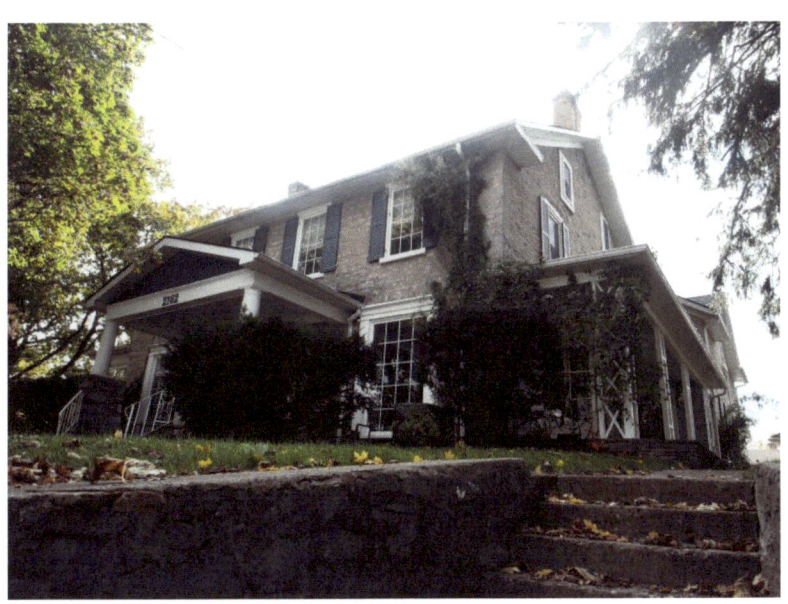

Architectural Terms

Acroterion: an architectural ornament placed on a flat base Example: Gore Mutual, 252 Dundas Street	
Belvedere: (from the Italian "beautiful view") an architectural feature on a roof, in a garden or on a terrace that gives a beautiful view. Example: 348 King Street East	
Brackets: a decorative or weight-bearing structural element which forms a right angle with one side against a wall and the other under a projecting surface such as an eave or roof. Example: 536 King Street East	
Buttress: a masonry structure built against or projecting from a wall which serves to support or reinforce the wall. In Canadian architecture, they are sometimes used for decoration. Example: 807 King Street East	
Capital: The uppermost finish or decoration on a column. Example: 808 King Street East	
Cobblestone architecture: Refers to the use of cobblestones embedded in mortar as a method for erecting walls on houses and commercial buildings. Example: 221 Dundas Street	

Cornice: originally the wooden overhang of the roof. With the use of stone, brick, iron and steel, the cornice is any projecting shelf at the top of a ceiling or roof. They can be very decorative. Example: 1010 Duke Street	
Cornice Return: decorative element on the end of a gable. Example: 630 Queenston Road	
Dentil Moulding: an even series of rectangles used as ornamental decoration in cornices. Example: 750-758 King Street	
Dormer: (French for "sleep") a gable end window that pierces through the plane of a sloping roof surface to create usable space in the top floor or attic of a building by adding headroom. Example: 358 Queenston Road	
Fretwork: interlaced decorative design resembling a bracket Example: 480 Queenston Road	

Gable: the triangular portion of a wall between the edges of a sloping roof. Example: 742 Duke Street	
Hipped Roof: a roof where all sides slope downwards to the walls with no gables. Example: 148 Dover Street	
Keystones and Voussoirs: a voussoir is a wedge-shaped element used in building an arch. A keystone is the central stone that locks all the stones into position, allowing the arch to bear weight. A keystone is often enlarged and embellished. Example: 807 King Street East	
Lancet Window: a tall, narrow window with a pointed arch at its top. Example: 567 Queenston Road, Preston – St. John's Anglican Church	
Mansard Roof: This style was popularized by Francois Mansart (1598-1666), an accomplished architect of the French Baroque period and especially fashionable during the Second French Empire (1852-1870). This roof is almost flat on the top section, with two slopes on each of its sides with the lower slope at a steeper angle than the upper and having dormer windows. Example: 1107 King Street	

Palladian Window: a large window that is divided into three sections with the centre section larger than the two side sections and usually arched. Example: 519 Queenston Road	
Pediment: a triangular section above the horizontal structure (entablature), typically supported by columns. The inside of the triangle is called the tympanum. Example: 807 King Street East	
Quoin: masonry blocks at the corner of a wall, often a decorative feature, usually larger or of a different colour than the rest of the wall. Example: 553 Duke Street	
Rose Window: a circular window with ornamental tracery radiating from the centre. Example: 745 Duke Street, St. Clements Catholic Church	
Vergeboards: also called bargeboards – hang from the projecting end of a roof and are often elaborately carved and ornamented. Example: 762 Duke Street	

Preston's Building Styles

Art Moderne, 1930-1945 – This style originated in the United States with rounded corners, smooth walls, and flat roofs. Large expanses of glass were used, even wrapping around corners. Example: 443 Duke Street	
Georgian, before 1860 – This style began with the British King Georges in the 18th century. These buildings have balanced facades around a central door, medium-pitched gable roofs, and small paned windows. Example: 531 Queenston Road	
Regency Cottage, 1830-1860 – This style originated in England in 1815 and spread to Ontario later in the 19th century as British officers retired to Canada. It is a modest one-storey house with a low-pitched hip roof and has a symmetrical front façade. Example: King Street East, Preston	
Gothic Revival, 1830-1890 – These decorative buildings have sharply-pitched gables with highly detailed vergeboards, pointed-arch window openings, and dichromatic brickwork. It is a common style in Ontario. Example: 149 Argyle Street South	

Italianate, 1850-1900 – It has wide-bracketed eaves, belvederes, wrap-around verandahs. Example: 606 Queenston Road	
Second Empire, 1860-1880 – The mansard roof is the most noteworthy feature of this style and is evidence of the French origins. Projecting central towers and one or two-storey bays can also be present. Example: 1170 King Street, Preston	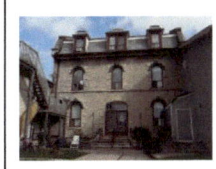
Queen Anne, 1885-1900 – This style is distinguished by an irregular outline featuring a combination of an offset tower, broad gables, projecting two-storey bays, verandahs, multi-sloped roofs, and tall, decorative chimneys. A mixture of brick and wood is common. Windows often have one large single-paned bottom sash and small panes in the upper sash. Example: 706 Queenston Road	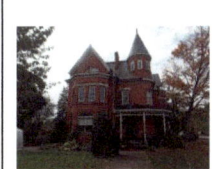
Edwardian, 1900-1930 – This style bridges the ornate and elaborate styles of the Victorian era and the simplified styles of the 20th century. Balanced facades, simple roof lines, dormer windows, large front porches, and smooth brick surfaces are its characteristics. Example: 722 Duke Street	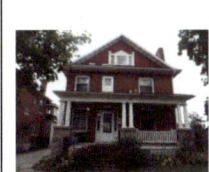

www.ingramcontent.com/pod-product-compliance
Lightning Source LLC
Chambersburg PA
CBHW040849180526
45159CB00001B/366